WITHDRAWN

MORAGA

DRAWING BASICS

An Artist's Guide to Mastering the Medium

MICHAEL WOODS

CONTRA COSTA COUNTY LIBRARY

3 1901 02732 5051

Watso s/New York

DEDICATION

To Rosina Barnard

ACKNOWLEDGMENTS

I would like to thank Daniel Goldsworthy
of Norwich Art Supplies for introducing
new papers and materials to me. Thanks
are also due to my wife, Jacqueline, for
checking and typing the manuscript, and,
above all, for her patient ear.

Text and artworks © Michael Woods 2000
The moral right of the author has been
asserted.

First published in 2000 by
B T Batsford
9 Blenheim Court, Brewery Road
London N7 9NT

First published in the United States in 2000
by Watson-Guptill Publications,
a division of BPI Communications, Inc.,
1515 Broadway, New York, NY 10036
Editor of American edition, Robbie Capp

Library of Congress catalog card number:
99-64665

All rights reserved. No part of this
publication may be reproduced or used in
any form or by any means—graphics,
electronics, or mechanical, including
photocopying, recording, or information-
and-retrieval systems—without the written
permission of the publisher.

ISBN 0-8230-1356-1

Printed in Hong Kong

Photography by Michael Wicks

Contents

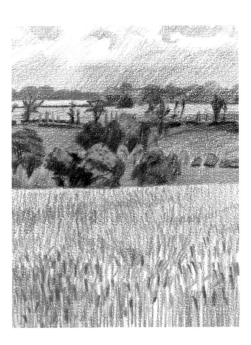

INTRODUCTION

One of the remarkable things about drawing is that it seems to be universally understood. While the meaning or interpretation of the images may not be, the process is. Since I draw outdoors a great deal, I meet people of all ages from a wide range of backgrounds. Many react enthusiastically to art, often commenting that they wish they could draw. I invariably suggest that they can, and should try—but, of course, I advise that it will take time to explore materials and techniques to draw well. The enthusiasm may be there, but without a lot of practice, success will be limited. And I always add that, personally, I feel the experience of drawing is not so much about making pictures as about observing and trying to understand the visual world and recording our responses to it.

A drawing may also be the starting point for other artistic expression, such as painting or printmaking, but in any case, gathering information is a prerequisite from the start. The artist's initial reaction to something seen, such as a shape or a ray of light, can charge a drawing with a precious quality that may be hard to recapture later.

In terms of technique, drawing is all to do with selecting the most suitable materials and deciding how they are to be used. Drawing is not in itself complicated, but what the eye sees and the brain attempts to unravel often is. A drawing can be a brief sketch done in minutes or a complex image involving hours of work. The exercises and demonstrations in this book range in drawing time from two minutes to many hours, all intended to help develop your technique and observation skills. Of course, you can translate my examples to your own subjects. There are no precise recipes given. Rather, this book's instruction offers basic guidance for drawing a range of appealing subjects from your own direct observation.

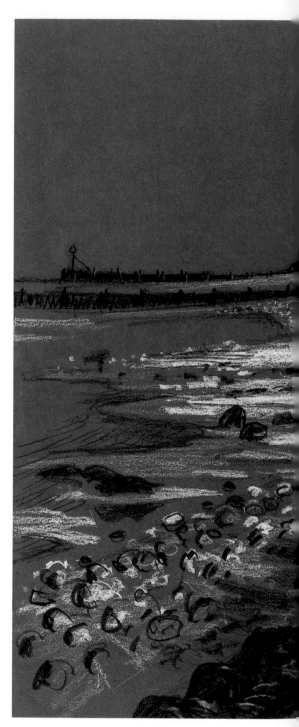

WEST RUNTON, NORFOLK, ENGLAND, *Conté stick*, 16 x 22 in (41

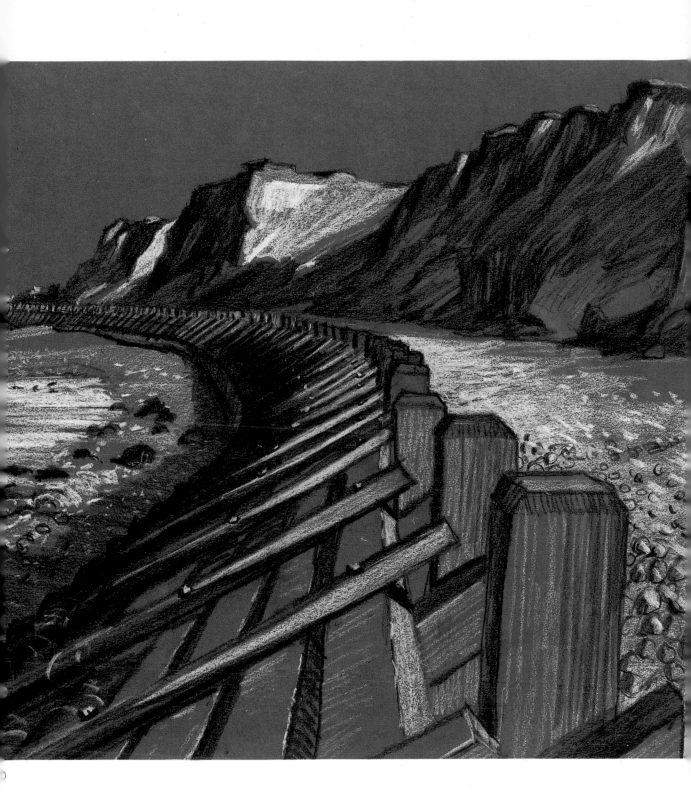

MATERIALS

The range of available drawing materials is very broad. It's best to shop at stores that sell individual items as well as complete drawing sets, as invariably some materials will be used up faster than others and will need to be replaced. Similar products made by different manufacturers can vary in their handling characteristics, so try to keep to the same brand. Suppliers usually furnish descriptive information about their products, so find out which are the best materials to choose for the work you plan to do.

PENCILS

Classic Graphite Pencil
The most basic drawing instrument, the pencil, comes in a range of tones. I recommend H, HB, 2B, 4B, 6B, and 9B. Of these, 2B is the most useful drawing tool, being neither too hard nor too soft.

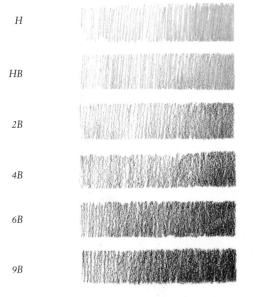

H

HB

2B

4B

6B

9B

Graphite pencils are graded from H (hard) to B (soft)

Large-diameter graphite pencils will deliver broad marks, but only when the whole tip is in contact with the paper.

Water-Soluble Graphite
These work in the usual way when dry, but if you wet your pencil marks, the graphite will partly dissolve to produce a tonal wash. Generally, three grades are available of which the middle strength, medium, is the most useful.

Water added to form a wash with water-soluble graphite pencil

Colored Pencils
Less intense than paint, these colors mix slightly when overlaid, but each individual hue remains somewhat visible. Available in a wide range of colors, palettes are suggested for individual projects in this book. For starters, select a lemon yellow, a warm dark brown, and a dark blue.

Tonal variation with colored pencils

Gray pastel pencils with soft covering power

Water-Soluble Colored Pencils

The boundary line between drawing and painting may seem imprecise, but water-soluble colored pencils do not really produce the quality of paint. By careful selection of a limited number of colors, however, the result can be quite effective. For starters, again select a lemon yellow, a warm dark brown, and a dark blue.

THE WHITE RANGE

The covering power of whites varies quite a lot. In this selection of seven samples, five are pencils. Choose a brand that has covering power, holds its point, and responds well to an eraser. Manufacturers offering a white pastel range include Conté, Faber Castell, Derwent, and Caran d'Aches.

Water brushed on for a wash with water-soluble colored pencils

Pastel Pencils

Pastels—both sticks and pencils— produce an immediate, sensitive mark, and deliver rich color, covering the paper well. Most versatile are pastel pencils, which come in a wide range of colors, are clean to use, and easy to control.

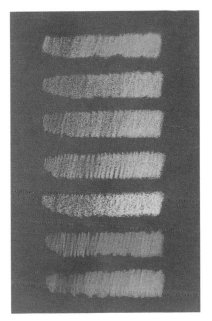

White range of pastel pencils and sticks

CHARCOAL

Available in thin, medium, or extra-large sticks of willow, charcoal tends to be rather gritty to handle but is useful for larger work.

Charcoal produces a rough but potentially expressive mark

CHALKS

Chalk is a broad term describing a short rod of pigment. When round and fairly soft, it may be known as pastels, and when square in section and harder, as chalk or crayon. Some can be dry, some very waxy, and others are termed oil pastels and have a creamy body. Conté "crayon" sticks are actually hard pastels and work well for bigger, bolder drawings.

NuPastel by Eberhard Faber is also a very popular brand that comes in dozens of shades. The square sticks are dustless, soft enough to build into layers, yet hard enough to be sharpened to a thin point for detail work.

Conté sticks in browns and grays

PEN AND INK

You can draw with any type of pen, but a dip pen (as opposed to a fountain pen) with a nib of your choice will produce a line capable of great expression. There are two major types of ink. One is water soluble, which when dry can be moistened with water and moved around. Fountain pens, pens using a standard ink cartridge, and dip pens all take water-soluble ink. The other type is variously described as waterproof, fixed, permanent, Indian, and acrylic. This ink when dry will not move when made wet again. Refillable pens must be specifically designed to cope with this type of ink, otherwise clogging may occur. Dip pens can be used with permanent ink but may need their nibs cleaned frequently.

Both types of ink are available in black and a range of colors that can be very powerful, although not all are lightfast. The ink can quickly be sullied by color being transferred by pen or brush, or even the wrong cap. Basic inks can be mixed to make variations of color.

Pens, Nibs, and Brushes

These vary enormously. Metal nibs can be fine or very broad, the latter possibly coming under a calligraphy heading. The quill pen and the reed pen will provide stronger drawing qualities and, closely related to these, brushes will also deliver a wide range of marks.

Dip nib and Indian ink

Reed pen with colored drawing ink

Rotring ArtPen and water-soluble ink brushed with water

Fine fiber-tip pen

Calligraphy nib, 1.5, and water-soluble ink

Broad and thin felt-tip pens

Reed pen and water-soluble liquid brown ink

Size 4 sable brush and acrylic waterproof ink

¼ in sable ox brush and Chinese stick ink ground in water

¼ in sable brush and waterproof sepia ink

Fiber Tips, Fine Felt Tips, and Broad Markers
Sets and individual markers are widely available. When markers are used for work to be framed, their permanence in sunlight can be limited, so take that into account. But markers are excellent for preliminary studies, exercises, or when you want to set down an image very quickly.

TIP

Hold a sheet of paper obliquely to a strong light source to determine its surface texture.

PAPER

As long as major wetting is not involved, almost all paper can be used for drawing. The thickness of paper is often given as pounds per ream (480, 500, or 516 sheets) of a specified size; the greater the pounds, the thicker the paper. A 60-lb. paper, in loose sheets or in pads of various sizes, will serve most basic drawing projects. For large compositions and/or drawings using wet mediums, choose heavier paper, such as 140 lb.

Paper Surfaces

The texture of paper, or its "tooth," varies considerably and is most noticeable in hand-made papers. A smooth paper is designated "hot-pressed," a good surface for most of the demonstrations found in this book. "Cold-pressed" paper has more texture. Paper with the most tooth is often called rough-textured paper, a good choice for showing broken drawing marks and brushstrokes when working with watercolors, water-soluble pencils, or inks. The absorbency of paper also varies considerably. For drawing purposes, acid-free and watercolor papers work well, while any paper listed for printing purposes may be more absorbent.

Colored Papers

Colored papers are appealing to use, but they should be tested for colorfastness if you're going to be using a fixative on your drawing. For quick studies, off-white newsprint (unimprinted newspaper) is an

Reed pen and ink

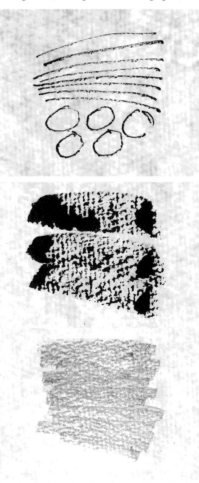

3/8 in sable brush and ink

Broad graphite pencil

More sharply defined drawing marks on smooth, hot-pressed paper

Rough-edged, broken drawing marks on handmade, rough-textured paper

TIP

When shopping for paper, take a portfolio with you to carry it home in. Never roll sheets, as it is impossible to flatten them once they have been rolled.

inexpensive choice, though its life is not long and its color will change. Brown wrapping paper, tissue, and textured papers can all be tried. With drawing pads, the spiral-bound type gives the best handling in its fold-back ability, while small, stitch-bound books are the most durable. A mixture of papers held on a clipboard offers the greatest choice in field work. In the studio, individual sheets are best. On a wooden drawing board, use pushpins; on a fiber board, use clips.

OTHER EQUIPMENT

Utility Knife
For cutting or trimming paper, mats, and for sharpening pencils, a retractable utility knife is ideal. Also called a craft knife, the blade is replaceable.

Erasers
Select white or colorless erasers of good quality. If cut in half diagonally, the wedge shape can be more precise in use. Plastic erasers are worth trying when using watercolor paper. Try a kneaded eraser for patting off an area to lighten a tone in pastel, chalk, or charcoal. But some waxy materials will not rub out easily, while other materials will smudge and clean paper will never be retrieved. Tests are always advisable, but the best rule is: Try never to depend on an eraser.

Lightfastness
For an artist, the crucial quality of lightfastness can be given a rudimentary test very easily. Cut a rectangle of white mat board (or any firm, white cardboard). With each color pencil or paint you plan to use, draw or paint a broad line across the rectangle and then fold it so that about half the length of the line is covered. If necessary, use tape or clips to keep the two sides close together. Place the test card in a south-facing window and note the date on the back. At weekly intervals, inspect the lines of color. The contrast between covered and uncovered areas will indicate lightfastness.

Fixative
Vital for work in charcoal and dry chalk, a spray fixative seals artwork and prevents it from smudging. Make sure you keep the can well away from the surface when spraying, and you'll get a better result by spraying lightly, building up layers as necessary. Be aware that spraying can darken paper and pigment and, with pastels, change the surface texture—many think to the detriment of the medium.

Always test a fixative first, before using it on your finished work, and always spray outdoors or in a well-ventilated room.

TIP

Always use an undersheet when drawing; the slightest dent or bump in a drawing board will show on the surface of the paper.

TECHNIQUES

Drawing can be summed up as the art of making lines. Two lines create a relationship, while their length and direction, qualified by their thickness and texture, become a definition. Lots of closely grouped lines can become tone.

Much of drawing technique is about how the hand can make these lines, how variations of hand pressure can influence their descriptive quality, and how the considerable range of line-making instruments makes their selection for particular drawings so important. The partnership with paper is, of course, a major consideration, but the simple line is an evocative mark that is surprisingly adaptable. Below are just a few examples of drawing marks.

USING PENCILS

The classic pencil is the 2B. It is hard enough to keep its working point, yet soft enough to produce rich, dark tones. All pencils are best sharpened with a utility knife to produce a long, chisel-like tip. Pencil sharpeners that are rotated do not uncover enough graphite, and the little round tip they produce is not very useful.

A graphite pencil makes good drawing lines and, gently applied, will produce an allover tone that can be varied in intensity.

Cross-hatching with 2B pencil

Any combination of marks can be used. Shading is the loose, general term for applying tonal areas with a pencil. Below, a gradation from light to dark has been made.

Diagonal close hatching with 2B pencil

Gradation of tone through control of pressure

The lines can be laid across one another to build up a darker tone gradually. This process is called cross-hatching.

Colored pencils will work in the same way, but where two or more overlap, a new color will be created.

Blue overlapping yellow produces green

A finger can be used as a stop for pencil shading. A left-hand finger making the stop can be moved to make the required contour as the right hand guides the pencil.

Finger used as stop for shading

(Left-handed artists should reverse the above procedure.) Gradation develops into modeling and is possibly best served by a soft pencil. Here, I have used a 9B on a semi-rough paper.

Modeling through variations in the tone

USING CHARCOAL

Charcoal produces a much richer and darker tone than pencil, but the scale of the marks is bigger and more appropriate for larger drawings.

Textured modeling with charcoal

Smudging

Smudging is best done with a finger, as below, though paper sticks can be used. Since they offer limited control, they probably best serve large-scale work. Paper sticks come in two sorts: compressed paper, called a stump; and rolled paper, called a torchon, or tortillon.

Charcoal smudged with a finger

Creating Halftones

Used with pencil and/or chalk, halftones can be created by allowing colored paper to show through the pigment. On dark paper, a light application will let the paper show through, making a midtone. On a halftone paper, the paper itself becomes the midtone, with paler and darker chalks used in relationship to it.

White chalk on dark brown paper with halftones created by variations in pressure

White and black chalk on gray paper which can become a halftone

USING PEN AND INK

Practice with a pen will help you gain good hand control. Straight lines close together will make a tone, particularly effective when viewed a little farther away than from the drawing position. Although the lines may be of the same thickness, the tone they create is controlled by their spacing. In the example here, the tone is slightly darker at the top where the lines are closer together.

Problem Shading

The type of shading seen below is often used by artists. It tends to be employed when something is seen and recorded quickly, with no clear decision having been made about the shape or tonal value. The zigzag line attracts undue attention, and once there, it is not easy to lose in subsequent overwork. Generally applied in haste, the continuous line results from not taking the pen off the paper. This can become a mannerism that may spoil, rather than improve, a drawing.

Problem shading

Dots

Because a pen line is so permanent, the dot is good for laying out a preliminary placement of shapes. Dots and dashes can become a surface texture that suggests a sparkling sea or an old wall, or they can be a variation within a line. Another type of dot can be a little space in a longer line.

"White" Shapes

A shape made by stopping and starting a series of lines can be tonally more impressive than making the shape with a boundary line and then working other lines up to it.

Lines making tone

Creating "white" shapes

Cross-hatching

A classic technique with a pen, tightly or loosely handled, cross-hatching will produce rich darks that retain sparkle as long as paper is permitted to show through. When paper isn't seen, the area dulls in density. Cross-hatching with colored inks can also produce a lot of vitality, but the colors that result from overlapping are not bright, and, in fact, become progressively darker the more cross-hatching occurs.

Building up tone with cross-hatching

Cross-hatching with color to mix hues and create tone

Lines and Dashes

Meandering lines and repeated squiggles can be evocative of special textures. Random dashes and marks can be valuable softeners in what otherwise can be a rather mechanical application of lines. Lines with curve, but in a more orderly fashion, can describe forms and may add movement to or aid the description of a surface.

Textures through creative marks

Curved lines create form

Using Felt-tip Markers

Markers produce a coarser line than most pen nibs. When worked closely together, felt-tip marks form a solid. This is partly because their spirit base soaks into the paper and the color spreads farther than the mark actually made. When newly applied, marks can be bright and are ideal for reproductive processes and for young children's use. But many markers are not lightfast, which tends to limit their use for artists.

Overlapping felt-tip markers

Using Broad Markers

Broad-tip markers have limitations similar to finer tips, but they do make powerful marks and can be ideal for creating large display graphics. However, for the artist's use, a square-ended brush and ink will make a similar mark with considerably more likelihood of permanence.

Black felt-tip marker

Overlapping felt-tip colored markers

Square brush and black ink for denser mark

Using Water-Soluble Ink

This ink flows well in refillable pens or when used with a dip pen. For small drawings, a little saliva on a brush is enough to wet some of the ink, which can then be spread to make shadows or other dark tones. If a large drawing is involved, water can be brushed on. The absorbency of the paper is important here, for ink will not easily move if most of it has sunk into the paper. On the other hand, if the drawing involves a lot of lines, too much ink may move and the wash will become over-dark. However, this technique will work well on most multi-use, acid-free papers. If the ink is a permanent or waterproof type, once it's dry, a wash of any color can be laid on top without disturbing it. This technique divides the image into two parts. The line describes the structural form, while the wash delivers color and tone to enrich it.

Water-soluble ink with water brushed on to create a wash

Waterproof ink with a watercolor wash added

Using Water-Soluble Pencils

Both gray and colored, these pencils offer a wetting option. The slight limitation of the colored type is that when dry, the pencil makes one color but when water is brushed on it, a different, paler tonality emerges. Let experimentation be your guide.

Water-soluble pencil with water brushed on

When dry, mixes of two colors produce a third color, and when wet, another three.

TIP

Stick ink is available in colors as well as black.

Color mixing with water-soluble pencils

Ink and Brush

This technique requires a no-hesitation approach. No alterations are possible, and much of the quality comes from standing back and using the whole of your arm to make the movement. It is not a process of filling in shapes. The character of the brush (and there are lots of brush types) will give the mark its shape. It is a hit-and-miss process, which depends on experience and practice.

Using Stick Ink

Oriental ink in stick form produces more subtle versions of drawings done with ink and brush. Instead of dense, solid black, stick ink creates gentle grays that are very effective in producing a gradation of tones. Using a diluted wash of stick ink with a dip pen, the resulting drawing can be quite delicate. Any lines that overlay one another become slightly darker.

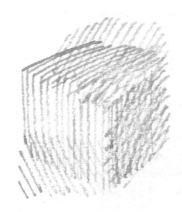

Stick ink and brush

TIP

If a drawing is laid out roughly and then developed, there is a danger of following marks that are not sufficiently accurate to form the basis of a well-considered structure. So, sometimes it's better to do a complete rough drawing to get the hang of a composition, then follow it with a fresh one, laid out with more precision right from the start.

Stick ink and dip pen

Expressive marks made with a brush and ink

LANDSCAPES

Those of us who are lucky enough to travel can enjoy seeing an ever-changing landscape panorama. Visiting a place for the first time often generates an enthusiasm that sparks new ideas and approaches to drawing. At home, the views that surround us daily may begin to go unnoticed, but even in our own neighborhood, sometimes particular weather conditions can show a familiar landscape in a new light. Drawing is a particularly good way of recording such moments.

The endless variety of landscape can seem daunting, but it doesn't take long before personal preferences begin to narrow our choices. With experience, you will learn that various factors, such as the weather or the seasons, will affect your selection of a drawing medium when working outdoors. In the following drawings, a variety of materials and approaches are used.

CHOOSING A VIEW

Drawing in the countryside on a summer's day is always a pleasant occasion, but selecting the right view needs careful consideration. You will be overwhelmed by information, so focus on a particular aspect of your subject, such as the quality of the light, the effects of the weather, or a certain vantage point. I selected the landscape on the facing page for the way the stand of trees and green fields separate the cornfield in the foreground from the fields beyond.

I used colored pencils on cream-toned watercolor paper. The position of the most distant trees was drawn first with a blue pencil. The fields in the distance are visually divided by the middleground trees, creating interesting patches of particular shapes. To keep the color vibrant, I did not apply the cornfield first and draw the trees over it. Instead, the amber yellow was applied next to the blue-green of the trees. Once these shapes

Palette of colored pencils

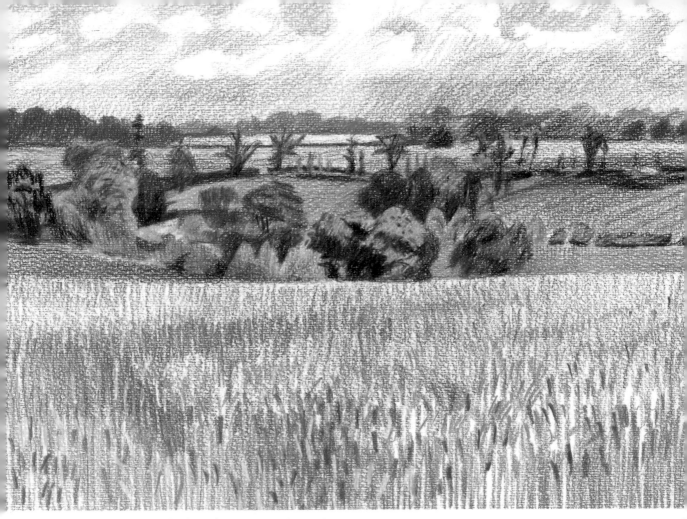

English Landscape, *Colored pencils*, 9 x 12 in (23 x 30 cm)

were established, it was possible to work downward into the woodland. It was important to convey how the light caught the tops of some trees when the sun was out, and these pale yellow-greens had to be preserved, while in contrast, other areas dropped into shadow or became darker-leafed trees.

The sky on the horizon had a purplish haze, and this darker color helped to make the light on the cornfields seem pale by contrast. For the near field, I used an initial layer of warm yellow, followed by variations to describe gaps in the crop. By this stage, all areas of the scene had been started, but none completed.

The second half of my three hours' drawing time was spent continually developing my palette relationships, strengthening the dominant color of each area: the cool blue-greens of the far trees, the yellow-greens of those nearest, and the texture, color, and tonal variations of the foreground.

TIP

When laying out a colored landscape, the use of a blue pencil will allow the marks to recede rather than jump out if any traces remain.

Demonstration

Black Conté pencils for bare winter landscape

I first noticed this strongly ridged field on a dull day and returned a few days later when the morning was bright. But in the end, the sky clouded over and there was only intermittent bright sunlight. I selected tan paper because it summed up rather well the day's very dry atmosphere. I chose black pencil because the trees were not in leaf and the hedge was more important as a tonal line rather than as a colored one.

MATERIALS
• Conté Pierre Noire pencil

PAPER
• Tan paper, 70 lb.

DRAWING TIME
• 2 hours

Method

1 I started by establishing the main directional lines with quite pale marks. These elements could be seen whether the sun was out or not. The space across this field is mainly described by the strong perspective of the ridges, and the perspective is established by getting the angles of the ridges correctly judged. The comparison to a vertical can help with this.

2 Now I developed the trees and the main hedge, using lines and areas of shading.

3 When the sun came out, rippling shadows across the ridges appeared, and each time this happened, I turned my attention to the drawing of shadows to describe the shape of the ridging. At

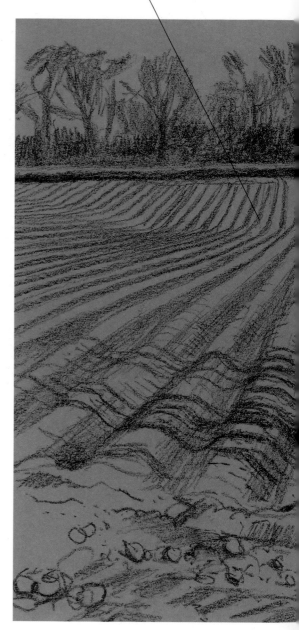

The curve of the ridges describes the hollow in the field

Ridged Field, *Conté Pierre Noire pencil,* 9 x 13 in (23 x 33 cm)

first mapped out lightly, the ridges were later strengthened, particularly those in the foreground.

Pierre Noire is a rich black pencil that smudges easily, so it is best to draw with your hand away from the paper, more like the holding position for a brush. Toward the end of the drawing period for this picture, the sun had moved and the shadows were noticeably different.

The main hedge is developed
with lines and areas of shading

The tone of the distant
trees is kept paler than
the near trees

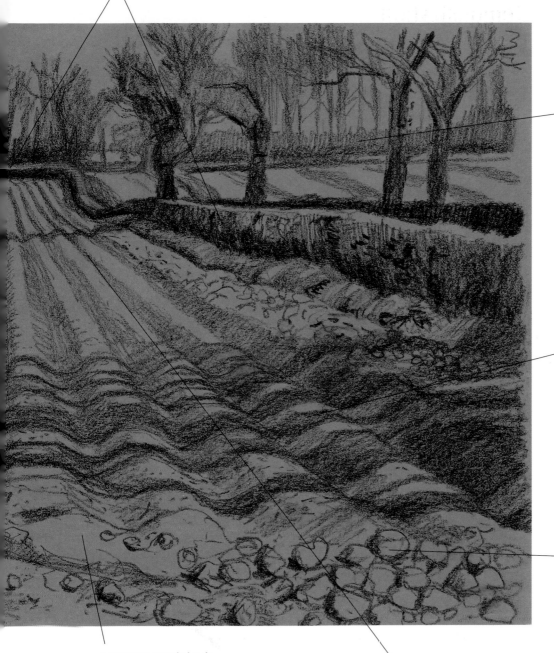

The rippling shadows
describe the shape of
the ridges

The large size of the
nearer stones helps to
bring the foreground
closer

Larger areas untouched in the
foreground help to give contrast with
the distant parts of the field

The strong perspective of
the ridges leads the eye
into the composition

TIP

Where shadows form a major part of a drawing,
establish them within the shortest time possible,
before the sun moves across the sky, and avoid being
tempted to alter or add to them later.

COLLECTING INFORMATION

Making studies of individual trees will help you to understand their structure, and your sketches can be used later as reference material. Trees that we pass by for most of the year without notice suddenly come to life in spring as leaves unfurl and blossoms open.

This tree (right) had marked curves to its contours, which prompted me to draw the blossoms first, using white Conté. I kept an eye on the overall shape while making blobs of white to describe the blossoms.

A black carbon pencil was used for the twigs, branches, and trunk, which had been distorted by bands holding it to a post, resulting in bulges.

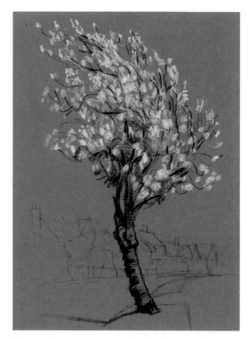

TREES (FIRST STUDY), *Conté and carbon pencils,* 12 x 9 in (30 x 23 cm)

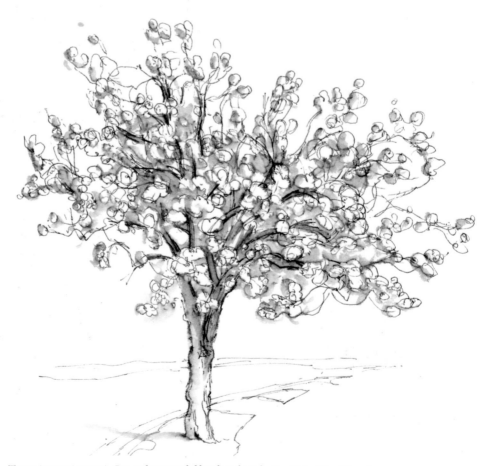

TREES (SECOND STUDY), *Pen and water-soluble ink and wash,* 9 x 10 in (23 x 25 cm)

For my first tree study (left), I used a very pale line to indicate the edge of a road and houses on its far side, grounding the tree in a suggested setting.

In a second study of another tree (opposite page, below), I drew the blossoms and branches at the same time, using continuous lines ranging over the whole tree. Here, the clusters of blossoms are described in a more linear way.

To accentuate the pale blossoms and suggest shadows, I worked around the blossom shapes with a small, damp brush to make a carbon wash. A little shadow at the base of the trunk established the ground and implied the direction of light.

LEAF STUDY

Studies of leaves can help enormously with the drawing of a whole tree. For this study of holly leaves, one dark blue and eight green pencils were selected.

In many places the leaves had pale edges, so some of the basic placing was worked out using the palest yellow-green. Any pale tones that I chose to eliminate as the drawing developed could be easily overworked with darker greens.

I developed all the leaves up to their midtones, being careful to keep color away from those areas where I wanted the lightest reflections on the leaves to be expressed by the white of the paper.

In the final stages, I brought all the greens up to their full strength, applying the richest and darkest blue-greens to define the twists of the leaves. The spots of reflected light were gently softened with a pale sharp green. Otherwise, they tended to look like holes rather than a shiny surface.

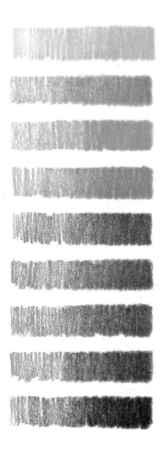

Palette of colored pencils for leaf study

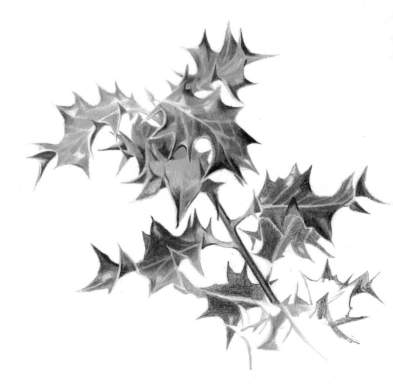

HOLLY, *Colored pencils*, 10 x 11 in (25 x 28 cm)

EXERCISE—GRAPHITE DRAWING

Pencil drawings made on location have value in their own right. They can also form part of an ongoing observational exercise that provides an excellent base of information for future paintings made in the studio.

Much landscape involving middle and far distance occurs within a very narrow horizontal strip. Here, the subject is a flat landscape, but even in more mountainous areas, ranges seen from a distance occupy a small horizontal strip of a potential picture's rectangle. The analysis of what happens in this strip is most important if scale and space are to be described. Pencil is ideal, for it can be used gently at first, but easily strengthened at any stage.

Stage One
The extent of the view is one of the first things to consider. Decide where at left and right your drawing will start and stop. Actually, the parts of a landscape are quite abstract. Sections of the horizontals, in this case the field, dyke, riverbank, and wood boundaries, have to be considered in relationship to one another.

Stage Two
Vertical elements such as fence posts, and areas that present a certain bulk, such as trees, bushes, and the negative spaces between them, begin to form a sort of grid.

Stage Three
A landscape may offer some variables, such as animals, but overall, there will be tree groupings or other clusters of shapes that will then act as anchor points.

Stage Four
As you work, the sky will possibly be changing, particularly the structure of

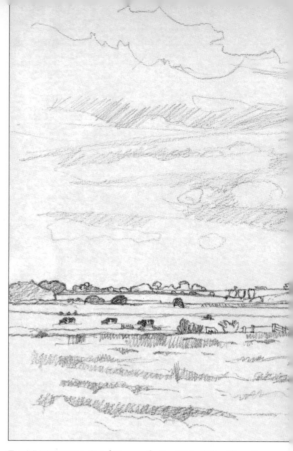

FLAT LANDSCAPE, *Graphite pencil*, 9 x 19 in (23 x 48 cm)

clouds, but weather conditions may be constant and shadow patterns may repeat themselves. Graphite pencil cannot show the difference between blue sky and gray shadow, so your drawn information will have certain limitations, but you can suggest the overall quality of the sky.

LANDSCAPE STUDIES, *Pen and sepia ink*, 2 x 19 in (5 x 48 cm)

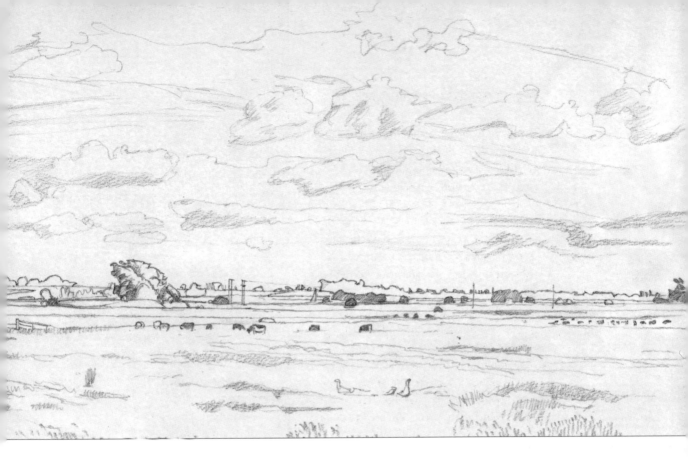

Stage Five

The foreground need not be the focus of a drawing. Above, the distant clumps and ridges are the focal point. Avoid overstating the foreground, for the feeling of space can be destroyed. Animals are useful in describing distance, since their size in relation to setting is readily understood: larger in the foreground, so when drawn smaller, they must be farther away. The human figure performs the same service.

SHAPES AND SHADOWS

The two studies below, executed with a pen and sepia ink, were made as a backup to some paintings I had created.

Drawn an hour apart in the morning, they provided me with excellent information about tree shapes, reed beds, and the shadows involved with both. I made the darker tones with clusters of closely drawn lines.

FOREGROUND SUBJECT

The foreground in a landscape can be developed as a drawing in its own right. Here, the previous year's reeds had dried out when I set about drawing them. Though seemingly complex, the interwoven rushes produced odd-shaped rectangles and triangles. Describing these intriguing shapes took me a long way toward depicting the shapes of stems and leaves.

I used brown to do all the basic drawing, in particular the dark parts in shadow. Then I chose a warm yellow to work over the areas in the strongest light.

I worked with a darker brown to strengthen some tones, and blue-gray to introduce variation in color and gradation in paler tones. The sample of a single reed shows the basic shapes, and clarifies how light and shadow can describe natures's turns and twists.

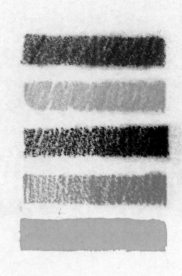

Palette of pastel pencils (Conté Nos 01, 20, 47, 54) and Cyan Blue acrylic ink

I kept the sky very simple, using a dilution of cyan-blue acrylic ink. A No. 8 brush was used for the largest areas and a No. 6 for the smaller ones. I constantly checked the gaps between reeds to make certain that the shapes and structure were being correctly interjected. "Filling in" should never be just that, for there are always some relationships that can drift and need to be gently modified. Finally, when everything was dry, I used spray fixative.

TIP

When working on a large drawing at an easel, a mahl stick can be used effectively to rest the hand, thus preventing smudging. This consists of a long cane or a slim rod of wood with a soft non-slip tip at one end; the stick is held at an angle with the tip resting on a drawing board or easel while the drawing hand is supported on the stick.

(Left) Study of a Single Reed

(Right) Reeds, *Pastel pencil and acrylic ink,* 21 x 15 in (53 x 38 cm)

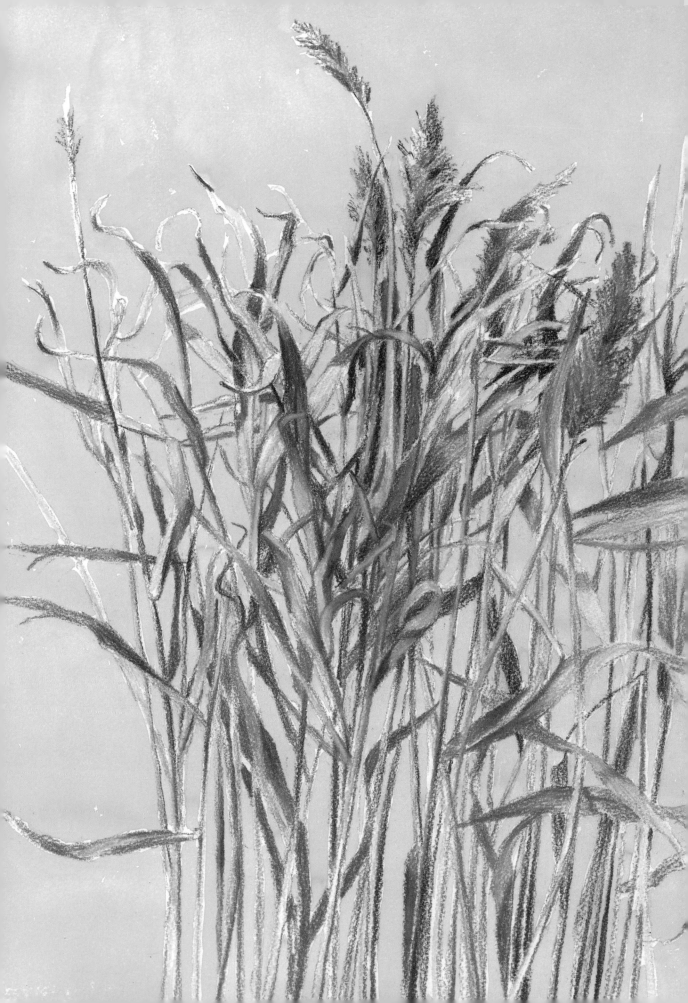

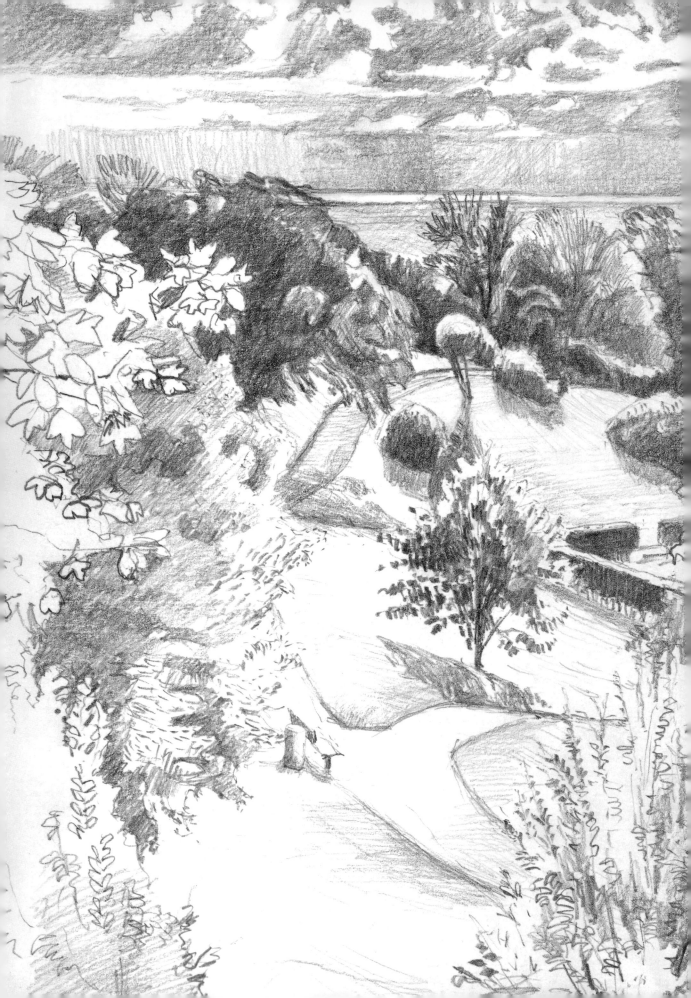

WHERE TO START

Sometimes nature takes a strong hand in how a drawing is made. I planned to draw this view of a park, with the sea in the distance, on a bright day. While preparing to start, the clouds in my view were building to an impressive cluster. Knowing that the formation would not last, I concentrated on the sky right at the start.

The sun was high in the sky so that light on the clouds was very bright. In order to suggest this brightness, there had to be a reasonable tonal contrast with the clouds in shadow. Yet, if this contrast was too strong, the tones left for the darkest trees would not have enough strength.

I used a soft, 6B pencil throughout for this landscape. Monochrome drawing, particularly where the graphite pencil makes at best a dark gray, has to be based on a careful distribution of tones in a well-considered plan. In this sky, it's difficult to tell cloud tone from sky tone, but it can be suggested through different marks.

The trees in the foreground were full of glowing and sparkling light. Since the foreground was the lightest part, it required minimal shading, just a suggestion of shapes. Thus, with a light foreground area, I allowed darker trees in the middle distance to dominate, both as the main focal point of the composition and, tonally, as the darkest shapes in the picture.

As my drawing progressed, the light and cast shadows were constantly changing. The sun was moving to the right and cast shadows to the left. Any really crucial elements needed to be put in as soon as possible. For the nearest textures, I used lines, dots, dashes, line shading, and loose cross-hatching. But nature had the last say when the sun disappeared behind a large bank of clouds, bringing my drawing session to a close.

Linton Gardens, Hastings, England,
Graphite pencil, 11 x 11 in (28 x 28 cm)

TIP

The tonal values and their description of space will probably be interpreted best when seen at a little distance. If there is a natural break in drawing, for example, while sharpening a pencil, prop up your drawing and view it from farther away.

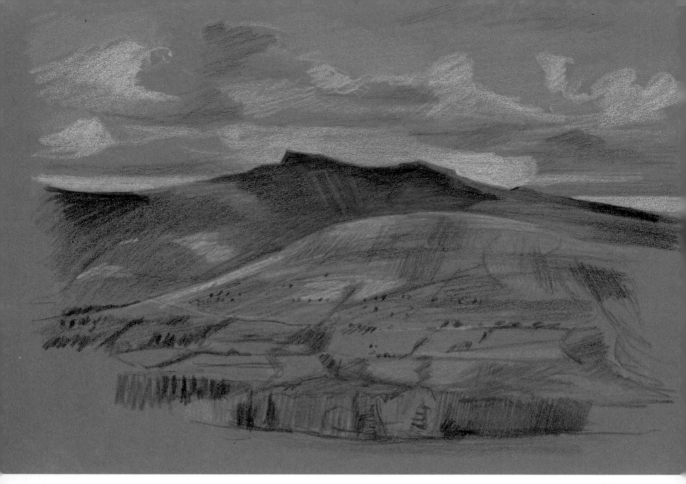

WELSH LANDSCAPE (FIRST STUDY), *Colored pencils*, 8 x 11 in (20 x 28 cm)

SUGGESTING SCALE

This drawing was made at Brecon Beacons, beautiful sandstone peaks in Wales. Drawing vast landscapes does pose a problem of size and scale. Use trees, the most identifiable elements of most landscapes, to plot the scale. Here, the farthest trees are dots made with a pencil tip. The distant peaks were in shadow, but nearer land was not. Cloud shadows rambled across the whole area. I watched what happened as they did, and then decided which light and dark priorities were best to depict.

I selected gray paper as a rich complement to a palette of many rich and deep hues created by twelve colored pencils. The darkest pencil I used was deep indigo. Other blues, yellow, and a sharp green were mixed to make varieties of green, completing my palette with ochre, terracotta, reds, pink, and white. During this drawing session, which was about an hour, several pencils had to be sharpened.

Palette of colored pencils

TIP

Instead of trying to hold a fistful of pencils, use a box or flat surface where they can be placed without rolling off.

DISTANCE THROUGH TONE

The considerable distances seen in this vista are interpreted as much with tone as with color. I worked with one white and seven gray pastel pencils on a midtone fawn paper.

White and two pale grays were chosen for the upper part of the drawing, leaving much uncovered paper to suggest blue sky. Using a midtone paper allows for drawing positive shapes with pale pencils. Here, the lowest part of the sky also defines the line of the hills.

The farthest hills are described with the paler and cooler-toned grays. As I watched cloud shadows run across the hills, I selected various moments to freeze the action.

The middle distance has the darkest tones, particularly the shadows on a sharp drop of hills at the far right of the drawing.

The foreground returns to paler tones, but each area occupies a bigger space, suggesting its closer range. The grassy foreground tufts drawn on raw paper are kept out of focus.

Palette of pastel pencils

TIP

Even if a drawing has been sprayed with fixative to prevent smudging, it is surprising how the surface can be marred when other drawings fall against it, as in a carried portfolio. Try, instead, to separate work in transport, and always store it carefully.

WELSH LANDSCAPE (SECOND STUDY), *Pastel pencil*, 8 x 12 in (20 x 30 cm)

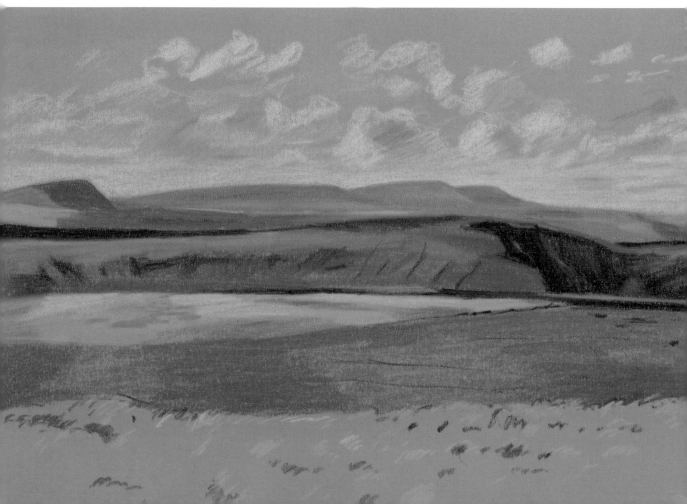

EXERCISE—CLOUD STUDIES

Using colored pencils for landscape reveals their limitations. They may define nature more closely than a monochrome pencil would, but the colors can be very unsubtle. For example, cloud shadows may look like a cool buff, but the nearest pencil to match it might be quite purple, so it will have to serve while being nowhere near the right color. Sometimes we just must accept that a drawing is a response to a subject translated loosely via the available materials.

To record clouds, you must often work very quickly. Only after you've started will it become clear how fast the clouds are moving, forming, and dispersing. These studies took ten minutes each.

TIP

When using sky studies in any later work, make certain that the light and wind direction relate to the ground information.

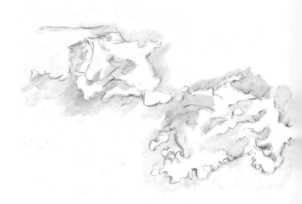

CLOUDS (SECOND STUDY), *Colored pencil*, 8 x 12 in (20 x 30 cm)

Stage One
Try to start as the clouds appear in the distance, and finish as they drift out of range. Two or three pencils are quite enough to do the job. If you use more, you may start inventing rather than recording what you see.

Stage Two
(Studies one to three) Having explored the cloud shapes with blues and purple, and, in study three, a bit of ochre, with clean water, wet the lines to create the sky color and to form cloud shadows, thereby showing up pale areas. By the time you have finished, it is quite possible that those particular clouds will have gone.

Stage Three
(Study four) For another study (here on a rough-surfaced paper), wet the paper first and then use the pencils on it. The damp paper will dissolve more of the pencil, making the image stronger.

Palette of colored pencils

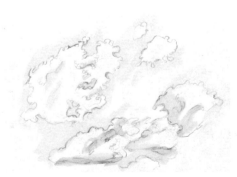

CLOUDS (FIRST STUDY), *Colored pencil*, 8 x 12 in (20 x 30 cm)

CLOUDS (THIRD STUDY), *Colored pencil*, 8 x 12 in (20 x 30 cm)

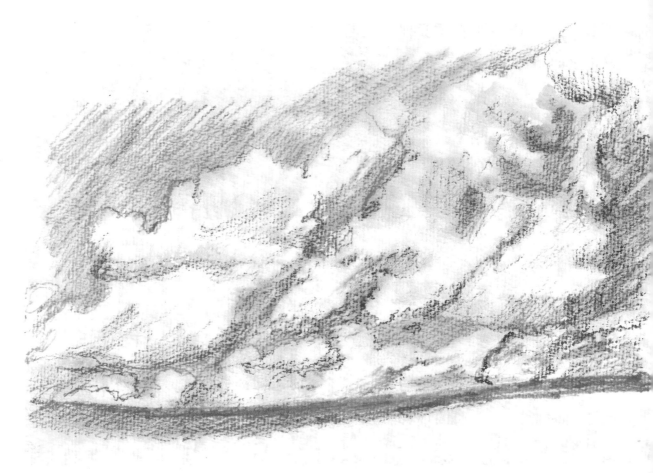

CLOUDS (FOURTH STUDY), *Colored pencil*, 8 x 12 in (20 x 30 cm)

BUILDINGS

Buildings lend themselves naturally to drawing, for lines make edges and buildings are full of edges. Buildings are also intimately concerned with people, and whether we live in them, use them, or simply look at them, they have a character that in many cases is worth recording.

Since so many buildings have matte surfaces, they can be interpreted effectively in drawings that are executed with dry materials. Structural details are also important. Pencil and pen can describe small moldings and edges with clarity.

It is possible to work on a complicated architectural drawing over several sessions, because an interesting structure reveals its characteristics without always needing exactly the same lighting conditions.

HOUSES ON DARK PAPER

The first view of a subject can often seem simple until, with longer consideration, other aspects make it more complex. For the drawing on the opposite page, I was attracted to the row of houses with their whites, creams, and pale pinks aglow in bright daylight. Their gardens contained small trees and shrubs, while the right-hand side of the road had full-size trees beyond which the houses disappeared. By using dark-green paper, the shape and tone of the trees could be suggested while still focusing attention on the buildings.

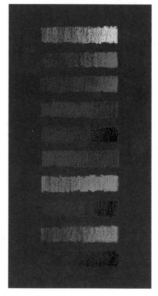

Palette of colored pencils

Using a freshly sharpened white pencil, I made very faint lines to establish perspective directions and proportions of the large main house. This enabled me to calculate the position of the gateways and sidewalk. Moving to the right, the rooflines descended, while the sidewalk lines rose.

Then I began creating solid areas of white, starting with the upper floor of the large house. Dark areas of balconies and shrubs were left as untouched paper, but were still treated as positive shapes.

My shading of the gateways was gentle until I established where light was crossing the road and falling on parts of the walls. In those areas, I strengthened the white.

I continued using mainly white until I got to houses farther up the road, where I added pencils of brown, red, and yellow to my palette. After I established the ochre roofs, I began working on the sky.

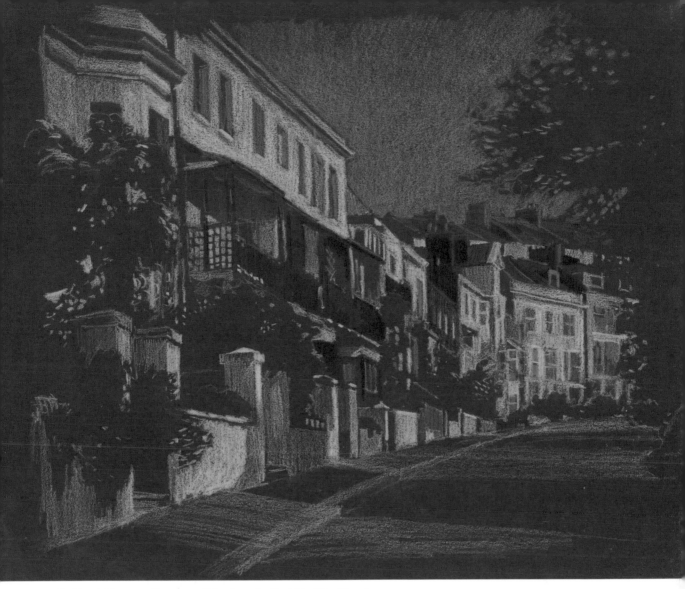

St. Mary's Terrace, Hastings, *Colored pencils*, 9 x 12 in (23 x 30 cm)

I chose a single blue for the sky, and to keep it translucent, used very little pressure in applying the color. Where it disappeared behind the tree, the marks became the tree's edge with glimpses of sky seen through the leaves. Note that parts of the farthest houses also peak through the tree's foliage as it moves down the page.

Not all the "white" houses were actually white, so some extremely gentle shading of yellow, brown, red, and gray produced subtle changes. A few areas of far roof and the near balconies were darkened with indigo-blue pencil. Finally, here and there I reapplied white to modify the pale colors and to make some of the structural parts catching the strongest sunlight a bit more crisp.

TIP

A dark blue like indigo is better than black for dark areas as it creates more atmosphere. However, if blue is applied over white pencil, it will become a very obvious pale blue. In such a case, a minimal application of black may save the situation.

DRAWING ON THE MOVE

These drawings were made while I was being driven through North Carolina. Since the car was traveling at a fair speed, I had to devise a way of recording these little buildings quickly, working with a broad-nib pen.

I looked ahead to select a likely subject. As we got nearer, I assessed its structure and started the framework, thereby establishing the perspective the drawing would take. Of course, my vantage point was changing all the time. The lines of the wood siding and corrugated roof were the last things I added as we passed each hut and it dropped out of sight.

Work on this technique by choosing a simple structure, observing its proportions, and then drawing its details from memory. Fleeting observations simply provide basic information which you then meld into a single, cohesive view.

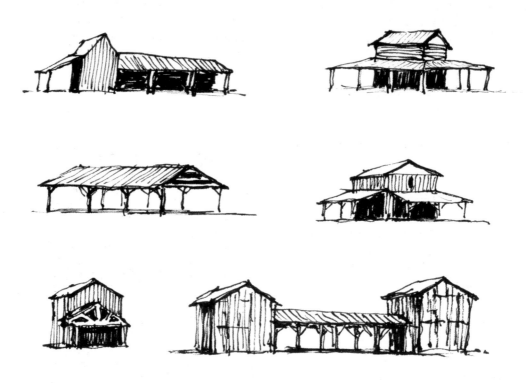

NORTH CAROLINA TOBACCO HUTS, *Pen and ink*, 8 x 9 in (20 x 23 cm)

DRAWING AS A TOURIST

Recording scenes as a tourist often requires speed. This sketch of the White House needed to be done very quickly, for many more stops were on my drawing schedule for the day.

I chose pen as my medium, using a line that is akin to jerky handwriting, briefly touching a shape and moving on. Then I added pencil to gave a bit of weight and

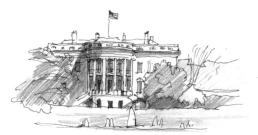

THE WHITE HOUSE, *Pen, ink and graphite pencil*, 6 x 8 in (15 x 20 cm)

Limited palette of colored pencils

shadow to my sketch. In less than five minutes, I was walking on.

ARCHITECTURAL DETAILS

This wonderful little building had at one time been painted white, black, and blue; the white still remained, but only fragments of blue and black. The roof had the most wonderful, rich covering of lichen and so demanded more than just a tonal translation. This drawing took about an hour.

I drew the structure with black ink. Shadows and darker tones were developed with a 2B graphite pencil, concentrated mainly on the chimney, gutter, windows, and base area.

The roof color and texture were developed with colored pencils, together with the amber-green of the lichen and the remains of the blue facade. Remember that with mixed media, a sequence may develop that is irreversible. In this case, once the waxy colored pencils had been added, that particular surface would no

longer take water-based ink, thereby limiting any later modification. It was important not to add any background that would detract from the building, except for a hint of shadow to establish a relationship between the building and the ground.

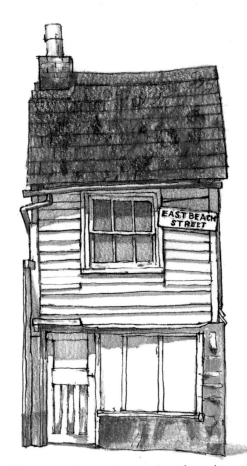

A BUILDING IN SUSSEX, ENGLAND, *Pen, ink, graphite, and colored pencils*, 9 x 6 in (23 x 15 cm)

Demonstration

Building up tone with colored pencil

With these fishermen's huts in Hastings, a town on the English Channel, I spent some time pondering which aspects would be given priority in my drawing. In general terms, these huts might be described as black, but actually, they are made up of a wide range of dark colors, weathered and changed by reflected light. Constructed of weatherboarding wood, they have strong structural lines, yet their overall mass seemed more important than any one textural part. The paper I selected has an even and soft-textured surface, and I worked with eight colored pencils.

MATERIALS
• Colored pencils (see right)

PAPER
• Soft-textured paper, 140 lb.

DRAWING TIME
• 1 ½ hours

Method

1 I laid out the simple shapes with black, applied extremely faintly. All my subsequent work was based on seven colors. For shading, I applied the pencils very flat to the paper, reducing the evidence of lines and preserving the paper texture.

2 The first tonal sequence was to establish the main distribution of dark and light right across the group of buildings. This application was quite gentle.

3 Then within each wall, I applied subtle variations of tone. Some roofs had a green cast from the lichen, and their

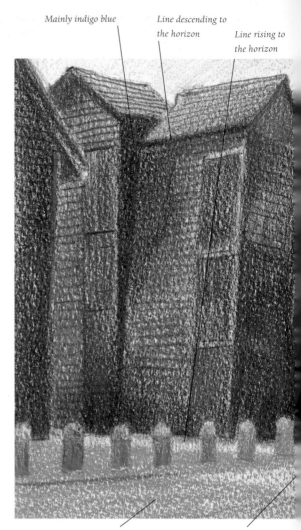

Mainly indigo blue *Line descending to the horizon* *Line rising to the horizon*

Road shadows a warm gray *Weather boarding lines*

upward-tilted surfaces tended to make most of those pale areas. Those hut walls that faced the road were receiving reflected light from it, so they were also paler than one might have expected.

4 I used indigo blue mainly for all the stronger darks. This was overlaid with terracotta and raw umber. For the road I chose raw umber and colored the shadows a warm gray. The sky took an extremely pale application of light blue, with bare paper suggesting hazy clouds.

In developing hints of color, I used a bit of parrot green, just enought to impart subtle sharpness, but after adding that nuance, that pencil was no longer needed.

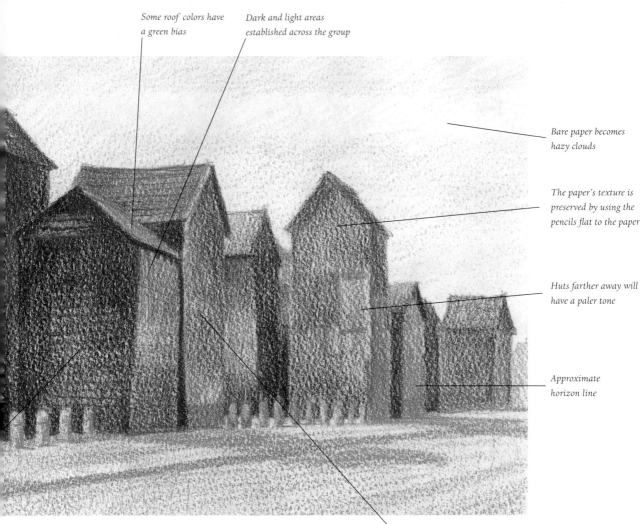

Some roof colors have a green bias

Dark and light areas established across the group

Bare paper becomes hazy clouds

The paper's texture is preserved by using the pencils flat to the paper

Huts farther away will have a paler tone

Approximate horizon line

Reflected light from the road

FISHERMEN'S HUTS, HASTINGS, *Colored pencils*, 9 x 12 in (23 x 30 cm)

Deciding not to use more green is an example of the actual drawing process influencing its own progress. When drawing outdoors from direct observation, we should constantly reassess our objectives to see if they are being achieved. Also, the same subject drawn on another day will not look quite the same, and your reaction to it will be different, too.

This whole composition illustrates several aspects of drawing buildings. The basic perspective follows standard rules. Lines above the horizon, at your eye level, descend to the horizon as they recede; lines below the horizon rise to the horizon as they recede. Structures of similar size appear smaller the farther away they are from you. These wobbly huts show subtle variations on these guidelines. Since they are broadly the same color and tone, those farther away are less intense in color and paler in tone, while contrasts in tone are less marked.

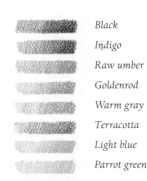

Black
Indigo
Raw umber
Goldenrod
Warm gray
Terracotta
Light blue
Parrot green

Palette of colored pencils

TIP

Regularly empty a pen
containing waterproof
ink, wash the feed and
nib elements, and refill
with fresh ink.

TIP

Test pens and pencils
on a range of different
papers to judge their
performance.

PEN AND WATERCOLOR WASH ON ROUGH PAPER

The April wind was bitingly cold on the island of Crete in Greece. Windmills stood in a line, looking more like castle defenses than structures for grinding corn. I selected these two because they still retained their sail assembly of poles, ropes, and wires.

Viewed from below, they were partly set against the sky. I chose rough buff paper so that it could serve as a middle tone, but it was almost too absorbent for fast drawing. My pen with waterproof sepia ink wasn't flowing too well, resulting in rather pale but lively, lines.

About four mixes of watercolor gave some solidity to the crude poles and stone walls, but the main wash was of white for the sky. Chinese white does not have much covering power, so more than one wash had to be applied before its density was right.

CRETE WINDMILL, *Pen, waterproof ink, and watercolor wash,* 12 x 9 in (30 x 23 cm)

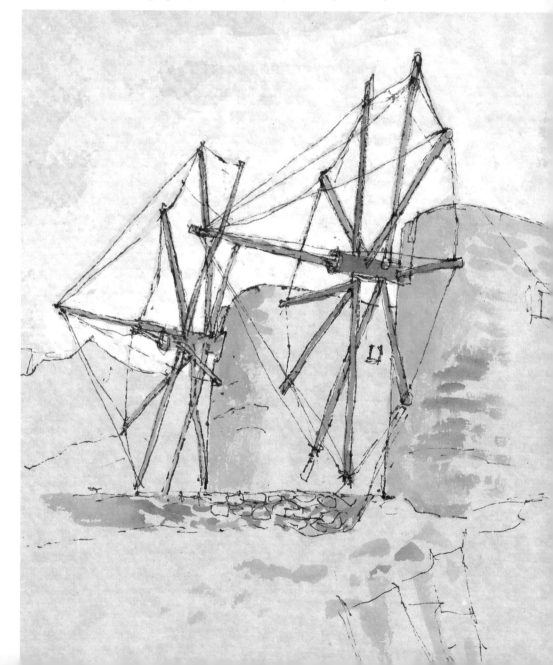

TIP

Titanium white
watercolor is widely
available in pan or
tube form and offers
greater opacity than
Chinese white.

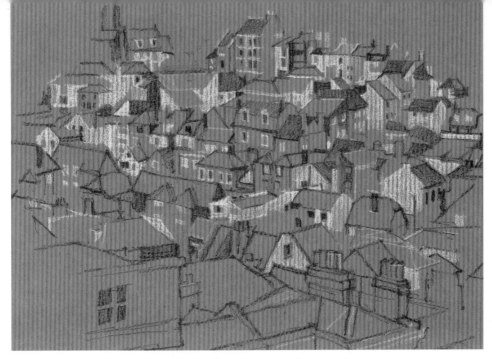

HASTINGS ROOFTOPS, SUSSEX, ENGLAND, *Conté pencil*, 8 x 10 in (20 x 25 cm)

EXERCISE—ON BROWN PAPER

Looking down on rooftops in any town or city reveals a fascinating panorama of shapes, colors, and textures that are special to that particular place.

Stage One
I chose the matte side of brown wrapping paper, for it provided a good tonal link with the amber and green roofs in this subject. The lines in my paper are, in fact, ridges, the darker ones being the crevices that show up quite strongly when using white pencil. I oriented the ridges vertically to follow the vertical direction of the house walls; horizontally could have confused perspective directions. To limit smudging, I started at top left and worked down to bottom right. (If you are left-handed, work from top right to bottom left.)

Stage Two
Many of the shapes in this drawing are related to diamonds and triangles. By employing sepia and white and leaving the paper as the midtone, the whole drawing is translated into three tonal values.

Stage Three
A cityscape composition can spread to great width if you choose to enlarge it. As the end of one building becomes the beginning of another, shapes and patterns are repeated and boundaries can be stretched.

So look at your drawing as a pattern and add shapes that complete each area. The nearest houses should present the larger shapes and the contrast between those and the smallest, farthest shapes will help establish perspective and a sense of distance across the rooftops.

HASTINGS ROOFTOPS (DETAIL)

TIP

When drawing, remember to push up or roll back loose sleeves to prevent unintentional smudging.

PEN AND MONOCHROME WASH

Edinburgh Castle stands atop a craggy outcrop of rock. It looks particularly dramatic with late afternoon sun making light and dark facets on its walls.

The main structural directions were clear. In fact, although there are so many variations of structural planes in the castle and surrounding walls, most were visible from my vantage point. But the light was changing and I knew that once sun fell on the left-hand walls, much contrast would vanish. So I worked quickly, completing my drawing in about forty minutes.

I used charcoal-gray watercolor in several strengths. For example, the roof of the main building is darker than its walls. Also note the contrasts created by shadows, as on the perimeter walls. When making a structural line drawing, it is best not to draw boundaries of shadows. When the wash is added, it will itself have a strong enough edge.

When I applied washes to the craggy rock, I used a dry brush so that the texture of my rough paper would create a scumble effect over the surface.

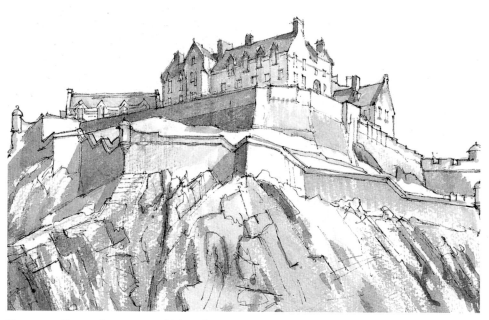

EDINBURGH CASTLE, *Pen, waterproof ink, and watercolor wash*, 9 x 13 in (23 x 33 cm)

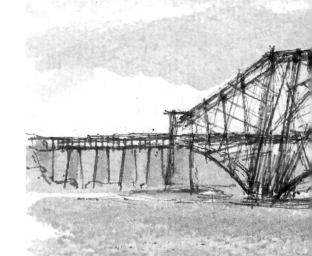

EXERCISE—BRIDGE STRUCTURE IN LINE AND WASH

The Forth River rail bridge is a stunning Scottish structure. The perfect drawing medium for it, sepia waterproof ink can be used in a Rotring ArtPen, and the tone is close enough to the bridge's actual color to demand its use.

Stage One
The horizontal band of the far shoreline and the line of the railway have to be considered carefully. Although waterproof ink is permanent, a few dots soon get lost when stronger drawing takes place later, so use dots to feel your way slowly, getting the shapes to fit together.

Stage Two
Study the main girder positions by observing first how they relate to one another, and then how their lines are affected by perspective as viewed from your vantage point. Of the two sections of the bridge being drawn (there is a third), the closer reveals its parts more clearly. This helps to sort out what is happening with the segment farthest from you.

Basic structure of bridge

Stage Three
Four simple, pale mixes of watercolor describe the water, landscape, and sky. Use a manganese hue of green-blue for the sky, with blank paper becoming low cloud in the far distance. With some indanthrene blue added to the manganese hue and then modified by a little raw umber, give some color to the far bank, the far piers, and a piece of near land on the right. Finally, a dry brush of indanthrene blue can be dragged across to describe the sparkling water.

Palette of pale watercolor mixes

(BELOW) FORTH RIVER RAIL BRIDGE, SCOTLAND, *Pen, waterproof ink, and watercolor wash,* 4 x 12 in (10 x 30 cm)

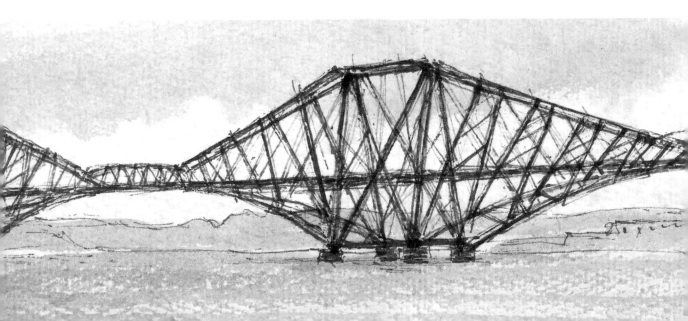

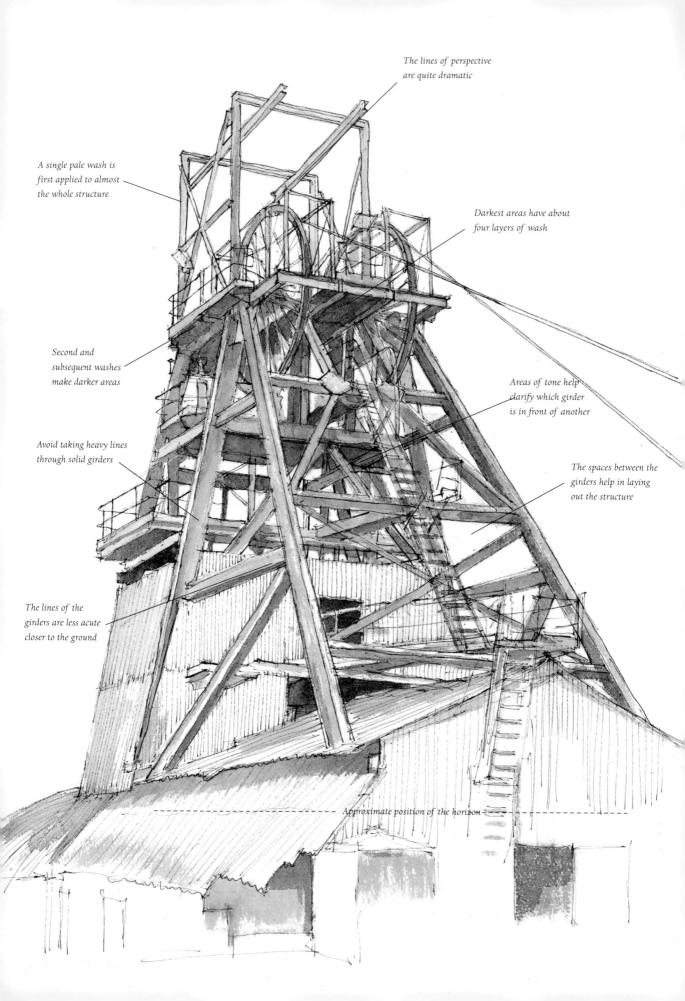

The lines of perspective
are quite dramatic

A single pale wash is
first applied to almost
the whole structure

Darkest areas have about
four layers of wash

Second and
subsequent washes
make darker areas

Areas of tone help
clarify which girder
is in front of another

Avoid taking heavy lines
through solid girders

The spaces between the
girders help in laying
out the structure

The lines of the
girders are less acute
closer to the ground

Approximate position of the horizon

Demonstration

Drawing a complex structure

The winding gear at the Big Pit is a massive structure that dominates its South Wales setting. It seemed a good idea to draw it from a low vantage point, which also meant working quite close to it. I chose a sheet of semi-rough watercolor paper measuring 15 x 19 in., which is about the biggest size that can be worked with on one's lap. It was a damp and misty day, so I used black waterproof ink to avoid any problems with smudging. In fact, I didn't have to worry, as the paper I used was so absorbent that the ink was practically dry on contact.

MATERIALS
- Rotring ArtPen
- Black waterproof ink
- Charcoal-gray watercolor paint
- $1/4$ in. square ended watercolor brush

PAPER
- Semi-rough texture, 140 lb.

DRAWING TIME
- 3 hours

Method

1 My initial layout of this complex structure took at least an hour. The task was greatly helped by observing the spaces between the girders (negative space) as much as the girders themselves (positive space).

2 Once I had drawn the framework, I worked over the whole composition with much stronger lines. The earlier faint lines stopped me from taking lines through solid girders where they were not wanted, at least in most cases.

3 In this drawing there are many lines crossing one another, and without a tonal wash it would be difficult to distinguish which were solid and which were areas around and between solids. First I applied a pale wash all over the main girders. Then I added a darker mix to some edges, giving the darkest areas about four applications. Putting the washes on in this way took about an hour.

4 By now it had begun to rain. I completed the drying process by using a hot-air hand dryer found in a nearby building, then I covered the drawing to protect it.

TIP

Always keep a small, folding umbrella in your drawing bag to protect your work if there is a sudden downpour.

(LEFT) BIG PIT, SOUTH WALES, *Pen, waterproof ink, and watercolor wash*, 19 x 15 in (48 x 38 cm)

COLORED PENCILS ON DARK-RED PAPER

It's odd that a drawing should come about because of the color of a piece of paper, but that's just what happened here, when dark-red paper perfectly reflected the quality of old brick buildings that I saw in Hastings, a town on the English Channel. As I wandered around soaking in the atmosphere of the old town, I came upon this intriguing passageway. The paper was exactly right for the scene.

The picture's focus was my starting point—the rectangle of light coming into the passageway from the street beyond. From there I laid out the buildings' proportions, using black ink in a Rotring ArtPen, working upward to the roof and then on the walls to the left and right.

Using a range of nine colored pencils, I tackled the passage rectangle again because the light there was to be the palest tone in the whole drawing. The sky was actually brighter, but it did not seem a good idea to pull the eye right up to the top. Some structural details also caught the light, especially the windows on the right.

Although the dark reds of the bricks varied more than the single tone of the paper, I ignored those gradations, choosing only to darken parts of the walls at the end of the passageway.

Overall, the picture reads as a dark drawing with some pale patches. The palette is controlled by limitations of the materials used, always a compressed range when compared with nature.

Palette of colored pencils

Post Office Passage, Hastings (detail)

(Right) Post Office Passage, Hastings, *Pen, ink, and colored pencils,*
13 x 8 in (33 x 20 cm)

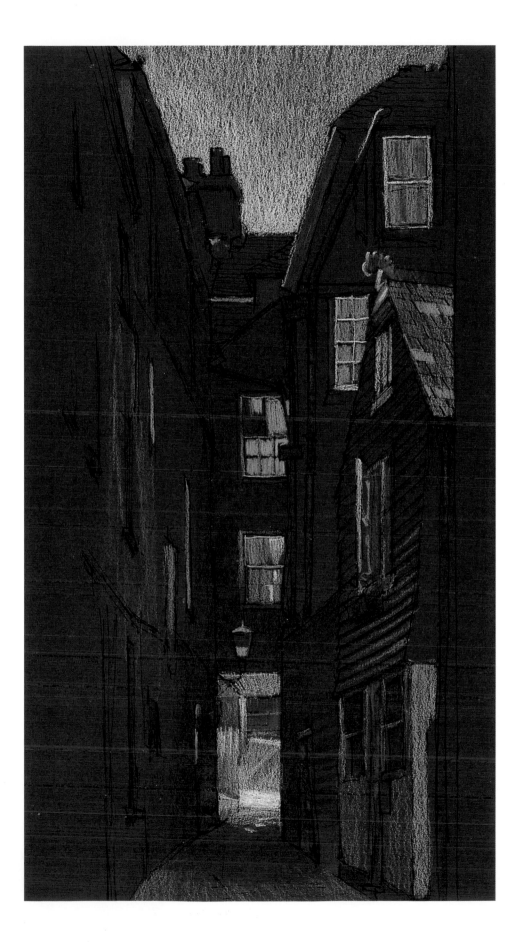

WATER

Although water is interpreted by artists in diverse delicate and beautiful ways, it always commands our respect for its power and changes of mood. But depicting water is complex because its surface reflects all that surrounds it, both from land and sky. Its own color varies from the milky green of Venetian canals and the ochre tint of some coastal waters to the strong soup green of many lakes and ponds.

Moving water takes many forms. A quiet, calm lake may still have a distorted reflection in it, while a cascading waterfall will produce shapes of foam and splash. Drawing materials have to be selected to complement the body of water in front of you in order to respond to its special qualities.

TIP

Keep a color sample card with your colored pencils so you can see what a particular hue looks like on paper.

TIP

Tonal relationships can be made clear if test samples are placed touching one another.

A PIER IN MIST

The coastline, comprising beaches, cliffs, seawalls, and piers, is rich in subject matter. On this misty day, the sea was only quietly making its presence felt. Two gray pencils and one white on a mid-gray paper seemed appropriate to capture the contrast in tones from foreground to background created by the mist.

I used pale gray to describe the pier in the background. Viewed against the light, it appeared quite flat.

The other, darker gray was reserved for the two seawalls. Each wave disappeared into the shadow of the farther one, but the shadow also showed up its shape. Waves hitting the seawall took reflections from the posts above. Then I added white to suggest sky reflections and ripples of foam.

HASTINGS PIER, *Colored pencil*, 7 x 9 in (18 x 23 cm)

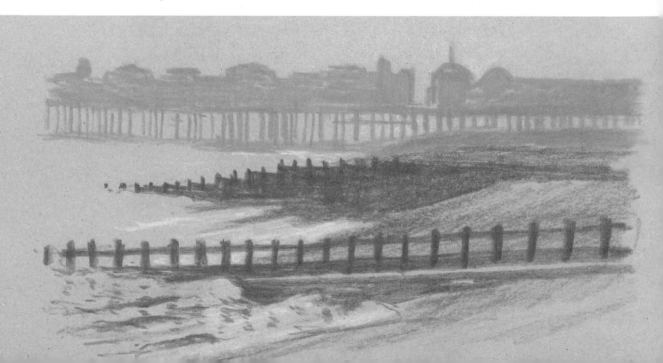

EXERCISE—TEXTURAL MARKS

The drawing below uses different techniques to distinguish four bands of texture, while subtle color changes in the gray pastel pencils add a little more variation. The waves hitting the seawall have a clear shape because their curves contrast with the horizontals of the stonework.

Stage One
Draw the waves first, establishing their shapes and position. Slightly curved lines follow the trough of the waves with patches of spray between them.

Stage Two
The seawall comes next, with layers of blocks establishing the lines receding to the left, but with area shading following the slight slope of the wall.

Stage Three
The hazy sky is drawn with short, gentle lines laid at an angle of roughly 45 degrees, suggesting the movement of clouds in the wind.

Stage Four
For the beach, use a light, flat application first, then follow it with dots and jabs which, in the darkest areas, are built up more solidly.

Stage Five
Make certain that the sky is finished first before you return to the seawall to draw the double handrail and upright posts. These must be carefully drawn, single-stroke lines made somewhat lighter as they recede, a bit heavier where closer to the viewer. The post intervals should diminish as they recede.

WAVES, *Pastel pencils,* 8 x 12 in (20 x 30 cm)

WAVES—HIGH VIEWPOINT

Looking down on ocean waves will help clarify how waves move. Look at the wave shapes and the rush of action when the wave breaks and falls over onto itself. Foam runs up on the beach while the bulk of the water runs back, undermining the waves that follow.

This study is about just that. A fishing boat had been beached and was about to be pulled up clear of the water. Standing on a harbor seawall, I watched and began sketching. People on the beach give an idea of scale. I described the distant sea with broken horizontal lines. Closer lines picked up the troughs between the waves, while nearer still they acquired shape and tone. The tone is needed so that the white foam of the breaking waves remains as mostly untouched paper.

SEA WITH FISHING BOAT, *Pen and acrylic ink,* 8 x 10 in (20 x 25 cm)

REFLECTIONS ON FLAT WATER

In this drawing, the water is quite still. River Wensum moves slowly under Bishop Bridge in Norwich, England. It was a bright April day and leaves were just beginning to appear on the trees.

Carefully considering my composition, I placed the bridge in the top half of my rectangle so that there was plenty of room to develop the water. Starting with the central arch and using dots, I calculated proportions and then moved left and right to establish the relationship among the three arches. This involved the parapet above and, because the right-hand bank is higher than the left, the ancient bridge is in no way balanced in all its parts. I also worked out the perspective of the wooden walkway on the bank where I was sitting. Finally, I drew the trees on either bank and beyond the bridge.

With pen, the allocation of textures is important. The water surface was lightly ruffled and the drawing describes it with broken and near horizontal lines. To give contrast, I used vertical lines on the left bank and the bridge piers. The tones for both can be similar, but the directional texture shows the change in materials. The bridge itself is made of a mixture of materials, suggested with different textural marks. Stone arches are headed by brick ones. Above, flint walls are completed by a stone and brick parapet. I began developing all of those areas.

Pen expresses texture quite well, but if strong light falls on a surface, less texture is visible so that white paper can be left untouched to create light. In dark areas, textures can be overlaid with hatching to create shadow, but the paper should never be overwhelmed and totally obliterated.

I translated what was happening on the bridge to its reflection on the water. The two main light areas in the water reflected the left-hand side of the piers. The light beyond the center arch created the arch shape, but the ruffled water surface fragmented it. The reflection of top of the bridge was broken by small waves.

The contrast between the bank area and water was useful. The regularity of the planking was quite opposite to the variable fragmented marks of the water, so to hold on to this valuable quality, I kept the bank area simple. A final tour around the drawing, strengthening the trees with a few more twigs and darkening a few of the richer areas, made me realize how the shadows had changed in two hours—a sure signal to stop.

BISHOP BRIDGE, NORWICH, ENGLAND, *Pen and ink,* 9 x 12 in (23 x 30 cm)

TIP

Winter views are often informative because it is surprising how much more can be seen when trees are leafless.

TIP

It is most important in pen drawings not to overwork all areas. If this happens, the result can appear very tight and leaden.

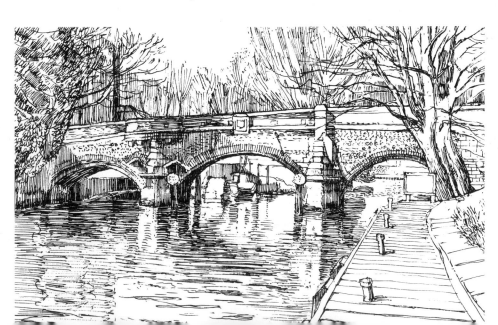

EXERCISE—REFLECTED LIGHT ON THE SEA

Sometimes a drawing has to be a graphic response to movement. This drawing is one of a series in which I analyzed the water's behavior, how the light was reflected, and which materials were appropriate to use.

Stage One

With the sun directly ahead but out of the picture, the strongest reflections come right down the middle of this drawing. The sea is sparkling finely near the horizon, so the application of white pencil has to be gentle enough to pick up the paper's texture. Once there, pencil will tend to adhere to itself, building little islands of pigment, thus allowing the hollows to remain uncovered.

Stage Two

Use black pencil to give the closer waves their shadows. This makes the gray paper a halftone. In other words, it helps make the paper a positive rather than a negative part of the image. The white pencil describes the texture and movement of the waves with expressive marks—short, jabbing strokes and meandering marks for the bright foam and reflected sunlight.

Stage Three

For the beach, an allover tone with some darker marks suggests the dry, solid quality of the pebbles without distracting the eye from the contrasting energy of the sea.

LIGHT ON SEA, *Conté pencil*,
9 x 11 in (23 x 28 cm)

TIP

When working outside, remember that the longer the drawing time, the more changes will take place within the subject.

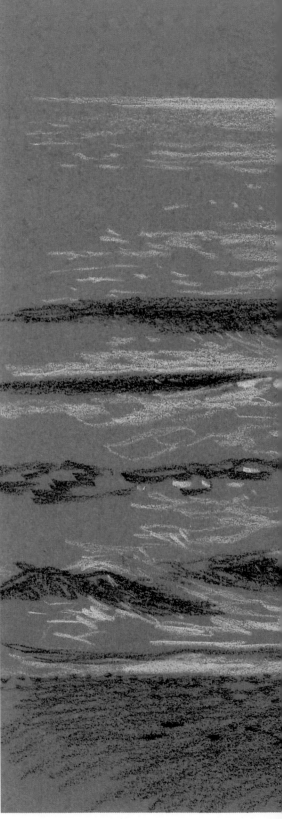

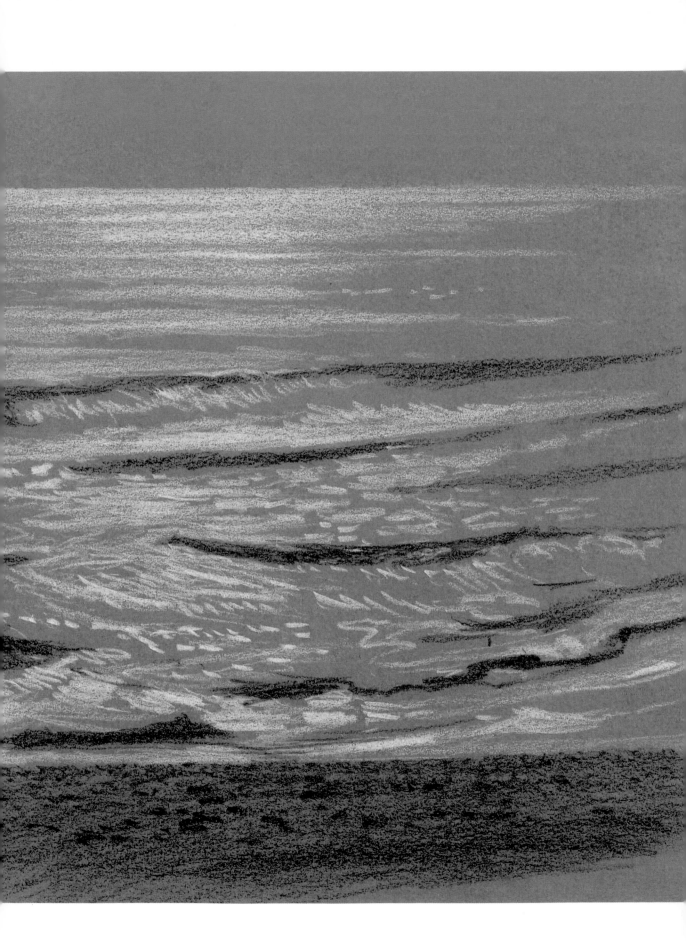

SEAGULLS AS MODELS

Seagulls can be very good models. Around fishing boats, where they fight for scraps, they seem not to worry about people and wait around hoping that more food may be thrown their way. You will have plenty of opportunities to use your drawings as reference when including birds in seascapes created later.

The method used here was to choose a bird close by and draw its stance as quickly as possible, using pen. Frequently, the birds would turn around, so I would make a second drawing on the same sheet. With pastel pencils, I then added the birds' strong, simple colors, even if the birds had moved away. Sometimes one drawing became the

Palette: pen, waterproof ink, and pastel pencils

amalgamation of two birds. After I had drawn four or five seagulls on one sheet, I sketched in a few stones. A little group of waders got the same treatment in my final drawing (below, opposite).

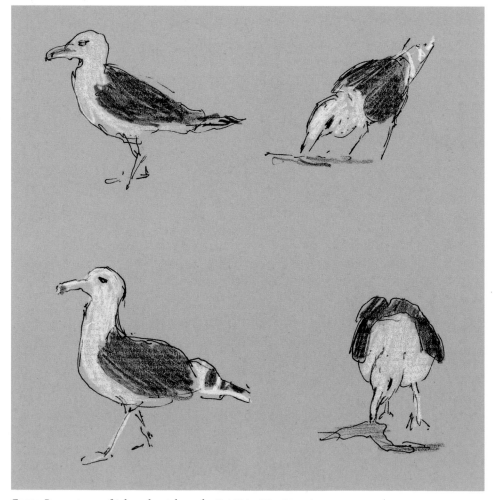

GULLS, *Pen, waterproof ink, and pastel pencils,* 9 x 13 in (33 x 23 cm)

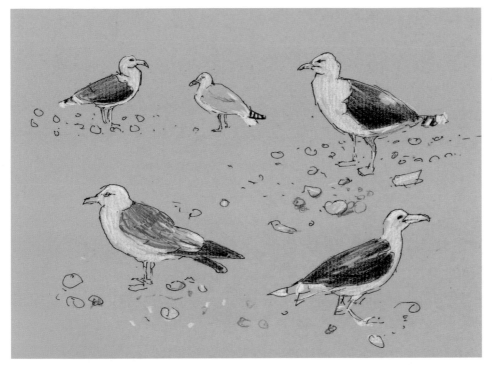

Gulls, *Pen, waterproof ink, and pastel pencils,* 9 x 13 in (23 x 33 cm)

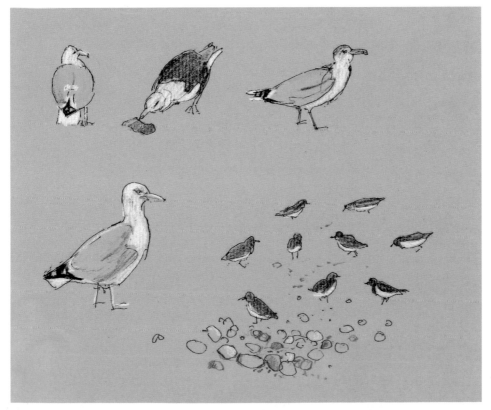

Gulls and Waders, *Pen, waterproof ink, and pastel pencils,* 9 x 13 in (23 x 33 cm)

Demonstration

Changing reflections on flowing water

In this part of England, river water is rarely totally still during the day. Breezes run across the water, ruffling its surface and changing reflected light patterns. You'll see that patterns and movement of the current often repeat themselves. Even so, it is very easy to start a drawing because of interesting reflections, only to find that they have disappeared before you finish. So it is wise to consider doing more than one drawing. The first may serve to familiarize you with recurring patterns, dictating how you tackle your second drawing.

MATERIALS
• Colored pencils

PAPER
• Semi-rough texture, 140 lb.

DRAWING TIME
• 3 hours

Method

1 Work in colored pencil can be surprisingly slow, for whereas in watercolor a mix for a specific color can be made and put on the paper in one application, pencil colors have to be worked one at a time, and gently at that, because if too much of one color goes down too early, it cannot be removed. On the other hand, because the making of colors is gradual, it gives you time to plan, adjust, and refine your marks.

2 In this drawing, the semi-rough paper surface breaks up the pencil marks, resulting in an almost pointillist quality that helps the color mixes. When working on white paper, each pencil's

Palette of colored pencils

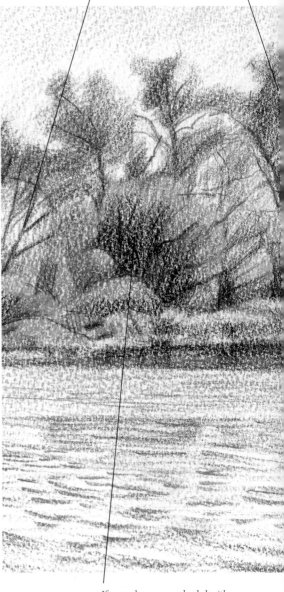

If dark colors are applied first, their tone will show through any subsequent application

The sequence of colors will influence the final blend

If paper becomes overloaded with pigment, stop drawing

color will have its strongest impact (as compared with working on a toned paper). The colors available, whether in a boxed set or a personally chosen range, will always have their limitations. Blues often will be too purple or too green, yellows too acid. The sequence of putting colors down will also influence the final hue. Generally, the last applied becomes dominant in the color sense, although if dark colors are applied first, their tone will show

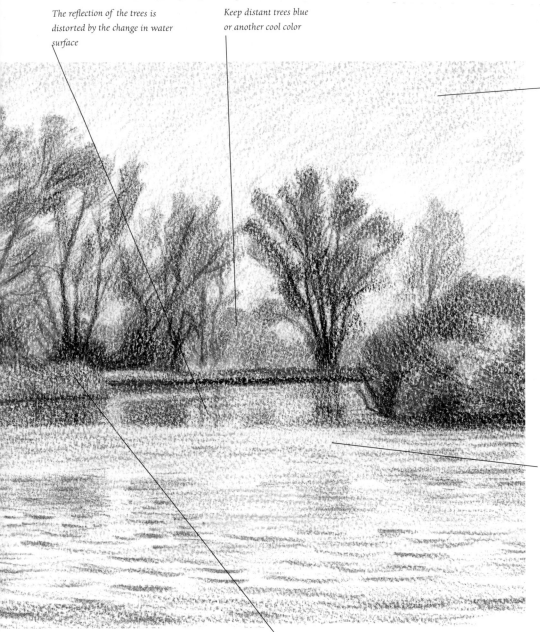

The reflection of the trees is distorted by the change in water surface

Keep distant trees blue or another cool color

The paper surface gives the drawing a pointillist quality

Breezes can ruffle the surface of the water

Build up colors and tones gradually

FLEET DYKE, *Colored pencil,*
8 x 12 in (20 x 30 cm)

through, even though their hue may be modified. Each brand of pencil has its own characteristics, and personal testing is the only way to assess its behavior.

3 In this drawing, it was important to map out the whole composition first, suggesting all the colors. Then tones and hues could be built up, but always with a choice of colors in hand. One color should never be used at its absolute full strength early on in a complex drawing, for then there is nothing in reserve. Here, when the water surface was changed by a passing boat, I continued developing the bank and trees. When the water calmed to its previous state, I worked on it again. Then, in the darkest parts of the trees and bushes, my color became saturated; that is, the paper texture was now obscured and the surface was becoming slippery. That was my signal to stop drawing.

WHITE WATER

Water can be seen in many contrasting states, as illustrated in these two studies. In Geneva, the Jet d'Eau is a plume of white water pumped up to a staggering height of 476 feet, while in South Wales, the water is cascading down over rocks. The drawing techniques required for each are quite different.

Fountain

I made the drawing of the fountain during a walk along the lake shore. Using my basic pen containing water-soluble ink, I put down the few lines for the fountain in about one minute.

With a small, slightly wet watercolor brush, I made the top of the fountain dark against the bright sky. Lower down, I made the background tone darker in order to accentuate the pale water.

The jetty and far shore were valuable

dark horizontals to give contrast to the vertical thrust of the water. Here, the overall shape of the water had to be described. Although flowing rapidly, its characteristics remained the same or were quickly repeated.

Waterfall

The waterfall presented different challenges. My view was much closer, so various parts of the falling water could be seen more distinctly. All my time was spent drawing the water; the rock boundary just contained it.

I decided to use mixed media. First, I drew the overall movement of the water with water-soluble ink. Starting at the top, the little rapids fell into a pool, then another series of rapids produced fanlike shapes until the major drop was reached.

The method here is to look at the top of the falling water and, as it falls, quickly move your head and eyes down with it. You will to some degree be able to freeze the action of the water as it falls—for, in order to depict water, you have to perceive its shape. I completed the pen lines down to where the water was exploding, then I cropped its flow at the bottom of my drawing.

My second medium was watercolor. I made a gray-blue blend of indanthrene blue and raw umber. Using a flat, 1/8-in. sable brush, I started at the top of the drawing and described the directional flow of the water with my brush. Darker areas of water made the falling white water stand out. The watercolor strokes also helped to describe the multidirectional flow of water over the rocks.

I changed to a larger, 3/8-in. flat brush. In the main fall, the dark shapes became holes in the cascading water, where the rock behind could be seen, while some darker areas were shadows where the tumbling water had a bulky shape.

TIP

A flat, square-ended brush has great versatility as it can deliver a broad area quickly, and also make a fine line with its tip edge.

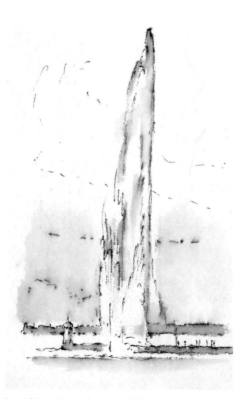

JET D'EAU, *Pen and water-soluble ink,*
5 x 3 in (13 x 8 cm)

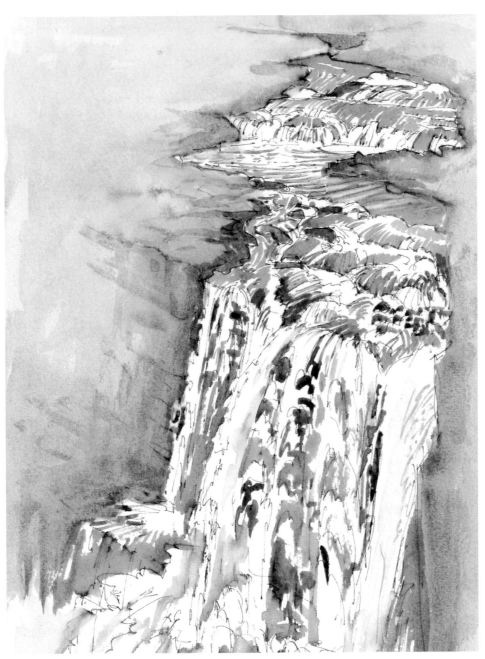

WELSH WATERFALL, SGWD CLUN-GWYN, *Pen, water-soluble ink, and watercolor,* 12 x 9 in (30 x 23 cm)

Watercolor mixes

Using a little Caput Mortuum, raw umber and indanthrene blue I gave substance to the rocks on either side and a pale tone in general to the land, so that only the breaking water remained white.

Demonstration

Reflections of buildings

Here is a challenging composition that combines several subjects and drawing techniques. The various elements need to be linked together—the buildings, trees, the bridge itself, and the reflections, with the water occupying the largest area. Curiously, to depict water in this case, we must draw everything else; the water then becomes apparent.

MATERIALS
- Pen and sepia ink
- No. 6 round brush; $1/8$-in. flat brush

WATERCOLORS
- Raw sienna, raw umber, brown madder, and indigo

PAPER
- Semi-rough texture, 140 lb.

DRAWING TIME
- 2 hours

Method

1 The bridge was my starting point, for the dominant shape is the oval created by the bridge tunnel and its reflection. Once I established those proportions, I drew the buildings upward from there. Apart from using a purely visual judgment, proportions can be checked using a pen, pencil, or brush as a gauge, sliding a thumb up and down from one end to measure. Hold your arm outstretched so the distance from your eye to the instrument is constant. To work out a reflection on calm water, measure the item vertically down to the water surface immediately below it, and then double the dimension. This can only be a rough guide because diminishing perspective may be involved, so keep checking your drawing against the subject in front of you. Also, note that even calm water has a little movement, and ripples will distort a reflected image. Note, too, that in this reflection, the bridge partly masks the buildings because they lie on the far side of it. To place reflections, it is helpful to consider verticals from the buildings above.

2 I painted my watercolor washes with a No. 6 round brush. To give the slightest hint of color, I made several mixes of raw umber, brown madder, and indigo. Some were warm, others cool. For the underside of the bridge fused with its reflection, I used the darkest tone. At its front edge, the reflection is a bit diffused by water movement. In reflections, tone contrasts are frequently more muted, making both dark and light objects darker. But sometimes, according to the condition of the water, very dark colors may reflect rather paler. Observation is paramount. Here, the white storefront has its reflection softened by a pale wash.

Any difficulty in dealing with paneled windows can be helped by using a thin, flat brush (here, a 1/8-in. sable). The window's sash bars are white, so they are described by leaving tiny gaps between the window panes, allowing paper white to do the job. Window texture is often quite important in describing a building.

FROME BRIDGE, *Pen, acrylic ink, and watercolor wash,* 12 x 9 in (30 x 23 cm)

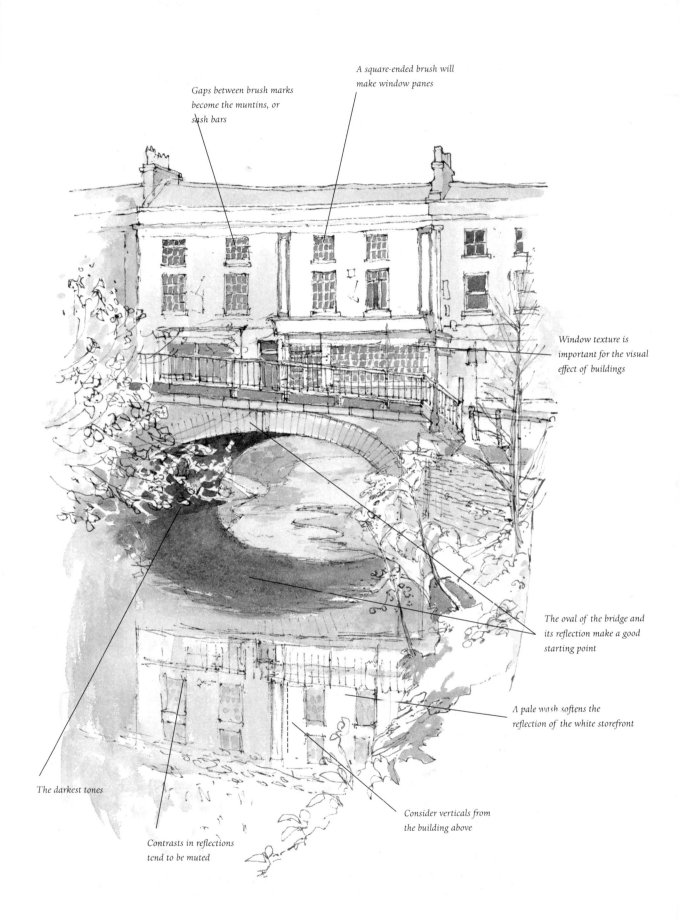

Gaps between brush marks become the muntins, or sash bars

A square-ended brush will make window panes

Window texture is important for the visual effect of buildings

The oval of the bridge and its reflection make a good starting point

A pale wash softens the reflection of the white storefront

The darkest tones

Consider verticals from the building above

Contrasts in reflections tend to be muted

FLOWERS

Flowers are wonderful things to draw. The way they grow, how their buds open, and the exquisite shapes of full blooms provide a wealth of subjects. They can be drawn indoors, which often allows longer working time, although making cut flowers look comfortable in vases is not always simple. Drawing flowers growing in a garden may be more natural, but you will have changing seasons, weather conditions, and quality of light to contend with.

WHITE LILIES ON DARK PAPER

TIP

Keep any initial marks extremely faint. They are there only as a guide. A positive line does not have to be a heavy line.

These lilies were set up in a studio. They were lit with spotlights, which meant that for the two days that it took me to make the drawing, lighting was consistent. As partially open buds were likely to open further, I had to draw each bloom at the stage it had then reached and more or less complete that flower before moving on to the next. However, I was in no great rush, so I planned the floral arrangement and my composition with care, making tiny marks on the paper to place the shapes.

I mounted dark brown-black paper on a wood board, placed vertically on my studio easel. My proximity to the flowers was such that I could draw the closest flower to me just about full size. This was also the first blossom I developed, because it was fully open.

One of the most difficult qualities to achieve in flower drawings is their translucency. Where we expect increasing darkness in the hollow of a solid, opaque object, frequently in flowers, the light will filter through. This occurred here, and accurate tonal observation was needed to describe the trumpet-looking hollow, as well as the filtered light farther in. White pencil lines were effective in describing the surface texture of the flower, with gentle shading applied to follow the curvature of the petals. I completed the first flower

LILIES (DETAIL)

before moving on to the one immediately behind and to the right of it.

The blossom in side view shows the length and shape of the trumpet. Varying positions of similar flowers can do much to help the interpretation of their shape. The fully closed bud came next. (In fact, by the time I finished the drawing, it had opened.) Then I drew the flowers on the left.

It was important to make the cluster of three flowers on the left smaller than the

LILIES, *White pencil*, 24 x 18 in (61 x 46 cm)

foreground flowers to give a sense of depth to the picture. Then I drew the bud at the upper left and the flower facing away from the viewer, which, being farthest away, was visually the smallest.

Although I had indicated the stem and leaf positions initially, I developed them only after completing the flowers. That way, I made sure that leaves didn't upstage flowers. Had foliage been drawn before the flowers had opened fully, the drawn leaves could have been in the way of the newly opened blossoms, confusing the structural space. I used subdued tones for the leaves so that they took nothing away from the whiteness of the lilies. Finally, I left the drawing on my easel so that I could look at it and consider all its parts from a distance over the next day or so. A strengthening of white here and there clarified a few forms, but apart from that, nothing more was done except to protect the finished drawing with spray fixative.

Demonstration

Strong colors in ink

With strongly colored subjects, the exact matching of pigments is less critical than with gentle tones. These anemones had strong colors and, on testing various ranges of inks, I selected six colors that turned out to be just right. Working in a studio, I arranged the flowers so that they could be viewed from above, placing my paper on a board laid flat on a table close by. Making two drawings of the same subject, I did all my work standing up.

TIP

Consider using a separate brush for each colored ink to prevent unintentional color mixing.

TIP

When using colored inks, washing a pen nib can be just as important as washing a brush.

MATERIALS
- 6 colored inks
- No. 7 round watercolor brush
- Reed pen

PAPER
- Semi-rough texture, 140 lb.

DRAWING TIME
- 1 hour for each study

Method

1 For the first study, I began with a light pencil drawing to get the feel of the layout and assess the sizes and relationships of the flowers.

2 Using artist's inks with dropper tops, I squeezed a drop of each color on a white china plate, leaving some space between and around them for mixing. With my round brush I painted the top flowers a weak wash of ultramarine, leaving its center unpainted. Full-strength ultramarine was then used to darken parts. I applied green and brownish variations to the flower's center, allowing the colors to mingle, wet into wet. I repeated the process with the neighboring blue flower.

3 All the leaves were added, making variations of yellow, blue, and brown mixes as they overlapped or became closely connected to other flowers. The leaves were almost dry when I completed the three remaining blue flowers.

4 The red flowers were dealt with in much the same way. First I used a dilution of red to cover the area, and then applied full-strength ink. Darker mixes were laid down while some areas of earlier applications were still wet. I was careful not to move the paper until everything had dried.

For my second anemone study, I used the same inks and roughly the same mixes, but applied the ink with a reed pen. Since I was working with the same layout, I bypassed penciling in, working directly with pen lines made very slowly. Areas of color were created by an accumulation of single marks, their direction following the structural lines on the petals. The white lines (untouched paper) state these and add more animation.

While I was drawing, the position of some flowers and stems changed slightly, so the weight of the group moved a bit to the right in my second study. Consequently, I decided to leave out one smaller blue flower on the right for compositional balance.

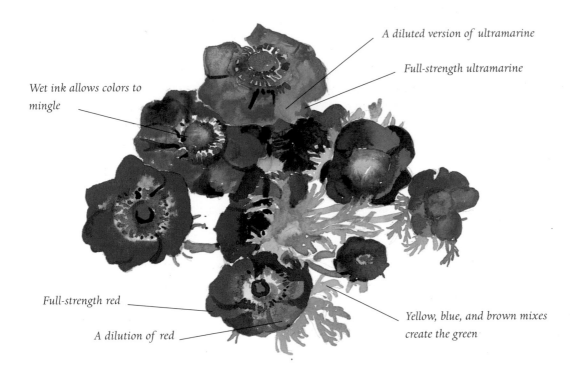

A diluted version of ultramarine

Full-strength ultramarine

Wet ink allows colors to mingle

Full-strength red

A dilution of red

Yellow, blue, and brown mixes create the green

ANEMONES (FIRST STUDY), *Brush and colored ink*, 13 x 12 in (33 x 30 cm)

ANEMONES (SECOND STUDY), *Reed pen and colored ink*, 12 x 12 in (30 x 30 cm)

EXERCISE—CROSS-HATCHING

This is a good example of a subject presenting itself by chance, rather than being sought out. I doubt that I would have chosen this still life ordinarily, but suddenly, looking down at the little potted plant in isolation from all others, I was inspired to draw it.

Stage One
Set up to work by covering a drawing board with dark paper, using push-pins to secure it. Then place the flower pot on a low table so that you will be able to see it from an overhead vantage point.

Sit on a tall stool with your drawing board placed flat on a table next to a bottle of ink. This vantage point, looking down at the tops of flowers, will allow you to depict certain details that cannot be seen when viewing a floral arrangement from a head-on perspective.

Stage Two
Start at the middle top of the flowers, and at the same time, consider the positions of the rest of the group. Once one flower is established, all the other proportions and relationships come from it. Use a few dots rather than lines, particularly where there is little or no tonal change; for instance, between two petals of the same color and tone. Don't be tempted to put a line around everything and then "fill in." This can produce an overstated and very wiry edge. Instead, the technique to follow here is to deal with one shape while you keep your eye glancing left and right, up and down. This ensures that all the contours fit together, growing into an overall shape that ultimately conveys the character of that particular plant.

Stage Three
Where there is tonal change, use hatching to make a first statement of the darker of

TIP

When a subject inspires you, try to draw it exactly as it is to retain the qualities that attracted you to it.

TIP

When cross-hatching is built up in very dark areas, the ink can remain wet for a considerable time. Don't continue until it is dry. Indoors, this can be speeded up with the use of a hair dryer.

VIOLETS, *Dip pen and ink,* 11 x 15 in (28 x 38 cm)

the two areas. You can add more lines later to create cross-hatching. If needed, the edge can be strengthened with further dots or a line. It is important to step back from your drawing to assess the tonal effect being created with your cross-hatching. Ration the really dark areas and try to keep the direction of application as varied as possible. If not, the lines can look very mechanical. Once covered, the white of untouched paper can never be retrieved, so preserve it at all costs.

The veins on the leaves were created by gaps in the clusters of lines and cross-hatching. Throughout the whole drawing, all the areas, including the background, were developed together. In this way, tonal control is maintained.

BRUSHED-INK BACKGROUND

The drawing on this page shows how a subject can be described with minimal marks, and how effective such flat pattern shapes can be. Here, a single stem holding five flowers is placed against a dark background. The blossoms are drawn by dipping a pen in ink and creating thin or thick lines, according to pressure applied to the pen nib.

The foliage is detailed by drawing fine lines that follow the contours of the long, graceful leaves. Finally, to develop the background, a round brush is used. In this example, you can see that my single coat of black ink dried unevenly, which I found appealing because it lent just a little texture to what otherwise would have been a very dead, flat ground. Note how carefully all the negative spaces within and around the flowers and leaves have been filled in.

ALSTROEMERIAS, *Dip-pen and acrylic ink, and brush,* 9 x 11 in (23 x 28 cm)

TIP

Try using a paper clip to prop a single stem in a particular position for a limited drawing period.

TIP

When applying ink with a brush, going over an area twice will give greater opacity, but edges are more likely to encroach on neighboring areas.

DRAWING WITH FELT-TIP PENS

When you use felt-tip pens, it's best to find a subject that doesn't demand too much delicate nuance, as markers are one of the least subtle of drawing instruments. Cheaper sets come in a restricted color range, and many brands are not very permanent. In my own lightfastness trials, some colors totally disappeared after two weeks in sunlight. However, for children, for short-term drawing, and where reproduction is involved, they can have their place.

Felt-tip pens, fine or broad, deliver clear, individual color. When several colors are used together, we can still feel the presence of each color; they stain the paper and overworking will not conceal earlier marks. Slowly made marks can have blobs at the ends. But to show what can be done with felt-tip pens, I selected a cheerful bunch of daffodils for this study, rendered with a palette of eleven colors.

I drew the flower heads using lemon

Palette: basic felt tips

yellow first. It was the palest tone, so other colors were likely to dominate it. The leaves were a blue-green and where they turned they caught the light. Since there was no felt-tip color anything like that, I chose the nearest to it, a royal blue.

The darkest rich greens in shadow were also a problem, for the purple-blue marker tended to overwhelm the greens.

I applied subtle variations on the flowers last, using gray and orange, partly because they were reasonably pale in tone and there were no other variations of yellow offered in the felt-tip assortment on hand, but I found the result to be quite appealing.

Bright felt-tip pens are the extreme end of the color-pencil approach to drawing. If they are to be used, you'll be more successful working with a restricted number of carefully selected colors from a set rather than being tempted to use them all—just because they are there. Children should also be encouraged to make a selection, possibly keeping to a color scheme of just reds and blues, or blues and greens, for example.

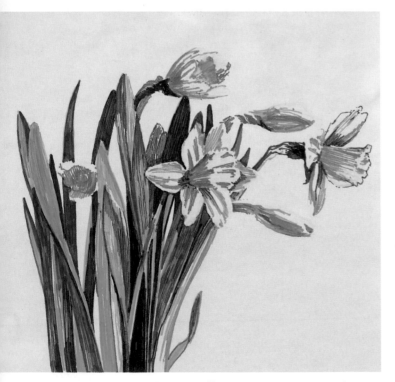

DAFFODILS, *felt tips*, 12 x 10 in (30 x 25 cm)

TRIALS FOR A HYACINTH

In contrast with felt-tip pens, colored pencils can produce very subtle lines and tones. Making several studies with Caran D'Ache pencils, first I used cream paper, but it did not show off the richness of my chosen hyacinth, so I changed to blue paper. Its dimpled surface picked up the pencil texture well and still allowed the paper's color to show through. Since this paper buckles when wet, I used the pencils dry.

I began by making a very pale drawing, using just the white pencil on the blue paper. The flower heads are very complex, and my structural drawing helped to locate the patches of color that I would develop later.

In this sort of drawing, it's a good idea to map out with small marks the many different colors you plan to use on all areas

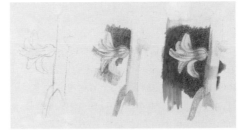

Trials on cream paper to assess color possibilities

Palette of colored pencils

of your subject. Once something is down, it is more possible to see how each area can be modified and the colors and their tonal values developed. The purple-blue of the flowers was a considerable test of the pencils; for one moment they were too blue, and the next, too purple. But overall, something of the flowers' crisp, firm shape came through.

I had worked on the background to help describe the shape of the flowers; now I developed its rectangular area fully. Toward the bottom, I applied white gently and completed the leaves. In shadow areas leaves are darker than the background; in lighter areas they are slightly paler. Had the two areas been conceived separately, this sort of relationship could be lost.

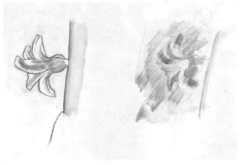

Trials on cream paper, looking at styles

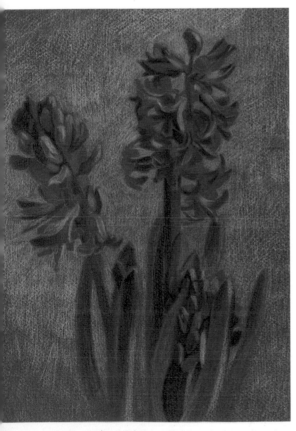

HYACINTH, *Colored pencil*, 12 x 8 in (30 x 20 cm)

Demonstration

Emphasis on structure

Tulips and their leaves have solid, bold shapes that can be captured well in drawings made with pen and black ink. Sometimes flowers appear almost too delicate to been drawn strongly, but the tulip shape can be very powerful, even rendered without color.

MATERIALS
• Rotring ArtPen
• Black ink

PAPER
• Hot-pressed paper, 100 lb.

DRAWING TIME
• 4 hours

TIP

When selecting flowers to draw, don't be rushed into a decision. Think of the implications of tone as much as color, and shape rather than prettiness.

TULIPS, *Pen and ink,* 10 x 16 in (25 x 41 cm)

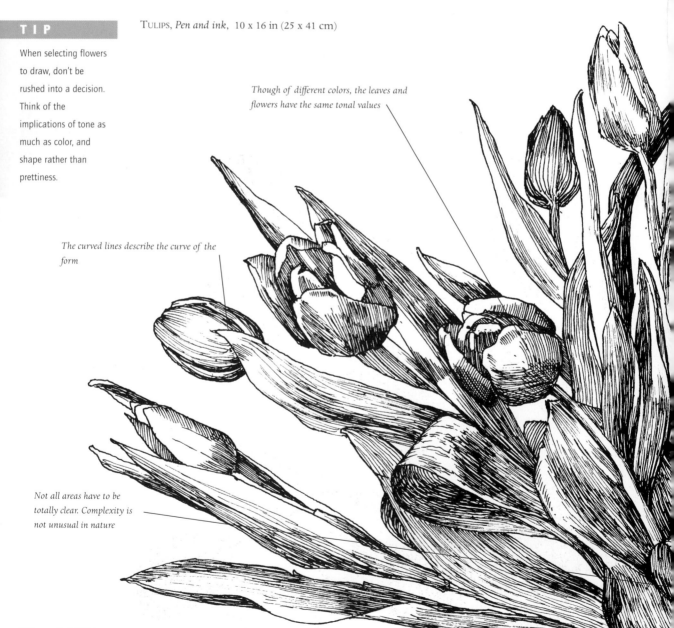

Though of different colors, the leaves and flowers have the same tonal values

The curved lines describe the curve of the form

Not all areas have to be totally clear. Complexity is not unusual in nature

Method

1 I started the drawing with the top-center tulip and worked my way out from there. Each leaf and stem shape had to be followed through to establish its direction and how it related to its neighbors. In almost all cases, my pen lines followed the growth direction. This was also the way I expressed the lined, ribbed texture of the leaves.

2 The tulips were red but had the same value as the leaves, so I treated everything in the same way in terms of tone.

3 In the lightest areas, I used a minimum of lines, while in the darkest, my lines stopped short of making a solid black. Maintaining the clarity of every part is always tricky in a monochrome drawing. Nature fuses things together visually, offering rich complexities that challenge artists and enhance their work.

Starting point

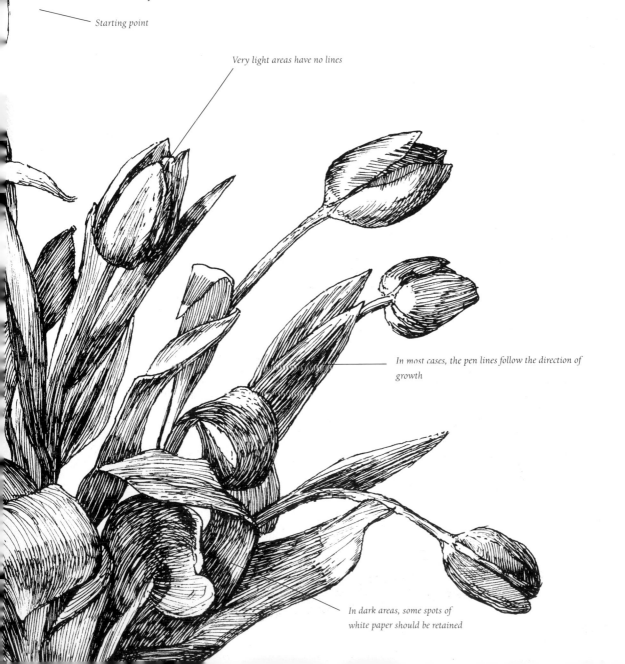

Very light areas have no lines

In most cases, the pen lines follow the direction of growth

In dark areas, some spots of white paper should be retained

Demonstration

Pointillist dots

In contrast to drawing with lines, you can use a system of dots built up in a pointillist fashion to create form and tone. This study of an iris in bud does just that. The beauty of this technique is that it builds very gradually.

I chose a Rotring ArtPen because of the variation in dots that it could produce. The ink in its refillable cartridge eliminated the need for dipping a nib into an ink bottle, and I chose smooth, heavy paper so that the dots would be crisp and undistorted.

MATERIALS
- Rotring ArtPen
- Black waterproof ink

PAPER
- Hot-pressed, 100 1b.

DRAWING TIME
- 1 hour

TIP

Never draw with a pencil first if you intend to make the drawing with a pen; by following a pencil line the pen can lose much of its vitality.

Method

1 I made this drawing in a terraced garden which provided me with a good eye level view of the iris. The modelling and the tonal description of color were achieved by the density of the dots. In some parts the two aspects fused together making the image a soft gentle one.

2 I started the drawing at the sweeping line between the calyx and the top main bud (see detail). Taking care to place dots in the middle of the forms and not at the edge, I established the proportions in height. These dimensions then controlled the placing of dots for the width which lead to the beginning of the development of the main bud.

3 I then drew downwards giving the main stem a slightly curved dotted line. From this the first small bud grew to the right and the second to the left. I gave the negative spaces between the buds and stem careful consideration as I made the dots, working from the middle of the shapes outwards, describing their fatness.

4 I was now able to proceed with the development of the dots. The densest and therefore the darkest areas were the dark tips of the buds. The modelling of round forms was gentler while in the light the dots became smaller and fewer in number until in the lightest places there were none at all. By working up and down the whole drawing I achieved the final unity.

IRIS (DETAIL)

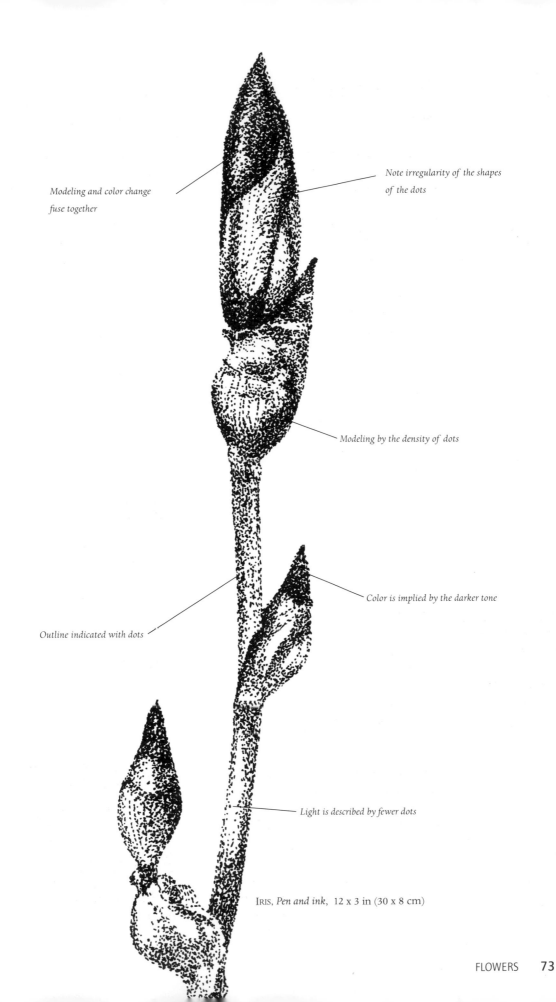

Modeling and color change
fuse together

Note irregularity of the shapes
of the dots

Modeling by the density of dots

Color is implied by the darker tone

Outline indicated with dots

Light is described by fewer dots

IRIS, *Pen and ink,* 12 x 3 in (30 x 8 cm)

DRIED FLOWERS

This study was a completely absorbing, two-day drawing experience for me. An excellent subject, dried honesty sprays, with their parchment like disks, will not wilt or die. Rather than place them directly in a vase, I put the stems in florist's foam, and to keep them from being too tightly packed, used two blocks of foam, then lit the arrangement by spotlight.

My working method was to focus on a little group of disks fairly central to the composition and have the drawing grow out from there. I tagged that part of the arrangement with a bit of tape to serve as a signpost so that as my drawing developed, secondary disks, stems, and twigs would be related to the starter group.

Twigs and stems weave through the disks, so they need to be tracked, first just by eye then, as their places are confirmed, drawn with faint lines. As your composition proceeds, the stems can be developed fully. Some will catch the light and others will fall in shadow. These variations, helped by white or black pencil, give the arrangement a sense of volume and depth.

Though a drawing like this may look complex, in fact, it is an accumulation of a lot of small, simple parts. If you belabor it too much, it will lose its delicacy. Honesty disks have a decided edge, which is realistically described by a line. The shiny membrane reflects light, and each disk will do so in a different way. Those in shadow are rendered more subtly, while those in brightest light show greatest contrasts.

HONESTY (DETAIL)

(RIGHT) HONESTY, *Black and white colored pencils,* 26 x 18 in (66 x 46 cm)

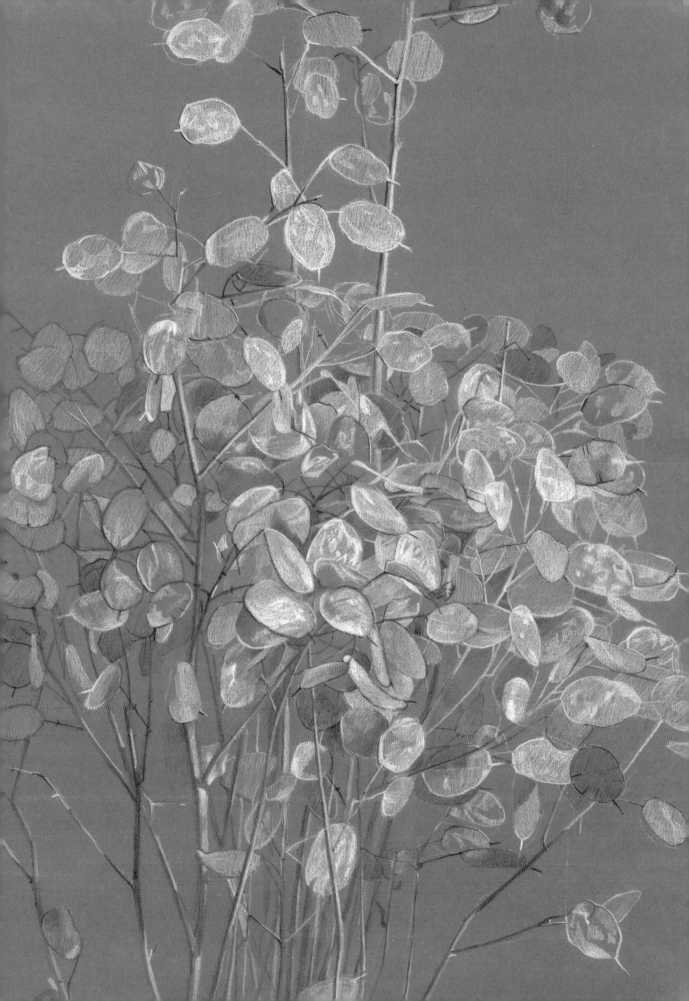

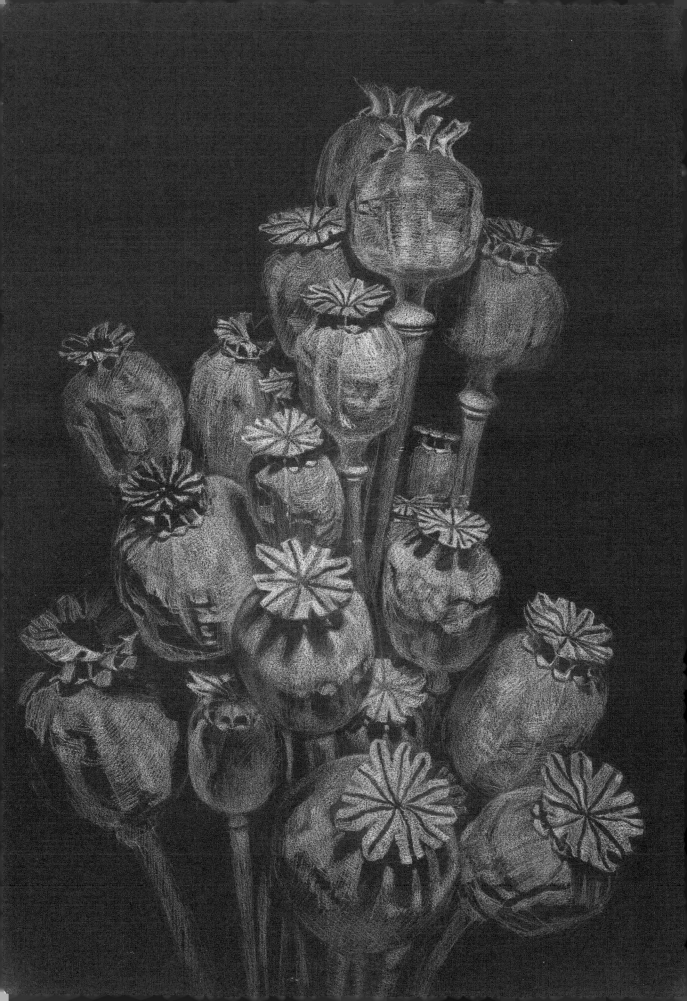

EXERCISE—LIGHT ON SPHERES

Whereas the honesty flower is basically a collection of little flat disks, the heads of poppies comprise a group of spheres. Again, arrange your flowers in blocks of florist's foam and point a spotlight on them from above. By enlarging them considerably in your drawing and using a pencil of standard size, you will be able to describe the flowers' many subtle changes in shape, shadow, and texture with greater precision.

Stage One
The overall arrangement has to be carefully considered and laid out with faint marks. Without this initial overall blocking, the many separate elements that make up the whole cluster could become quite confused.

Stage Two
Working on dark paper, describe the lightest part of your picture with full-strength white pencil. Gentler marks become halftones while untouched paper becomes the darkest parts of your composition. Because the heads are more or less the same color and tone all over, their shape is described by the light or lack of light falling on them. In many areas, let your pencil lines follow the contours of the poppy, working either down it or across it to form cross-hatching. In other places your pencil can be more randomly applied.

Stage Three
In a relatively large drawing, it takes time to build up marks to construct the main light areas. But only then can subtle adjustments begin to be made where the strongest lights build up. It is very important to move gradually, always reserving your heaviest application of

white pencil for that final, brightest highlight you might include. Even if you never quite use it, it does mean that you remain in control. Once the lightest lights are set down, the only avenue for further contrast is to make darks darker, and in this case, that is not possible. An eraser would disturb the pencil shading and tend to blur it. A kneaded eraser may lift off some tone, but you can't depend on it.

Stage Four
Work around your drawing, strengthening shading here and there to give balance and harmony to the whole composition.

DRIED POPPY SEED HEADS, *White pencil*, 22 x 16 in (56 x 41 cm)

DRIED POPPY SEED HEADS (DETAIL)

STILL LIFE

TIP

Ink bottle caps that have no color identification can be spotted with white correcting fluid and then colored with the ink the bottle contains.

The very mention of the words *still life* brings back memories of school art classes and the great Antique Room at the Slade School in London. Still life can provide lots of colorful subjects on a gray winter's day, offering colors, shapes, and textures that are enjoyable to draw.

To progress as an artist, exploration of techniques and materials is vital, and still life gives you ready and frequent access to subject matter, allowing you to practice just as often as you wish.

Working with objects on hand and/or shopping for things to draw offers endless choices. Select a rich variety of fruits and vegetables, and among your household accessories almost any object can take the stage in a still-life arrangement. When selecting items, consider the drawing materials that you might use to interpret your still life.

Many exotic fruits are ideal as subjects for drawing. The selection here consists of kiwi, coconut, lychees, kumquats, star fruit, and satsumas, all chosen for their shape and color. I piled them into a blue-and-white patterned bowl whose broad rim provided a decorative band that complemented the fruit colors, cool blues contrasting well with warm reds, oranges, and yellows. I lit the arrangement by a spotlight from top left.

Using colored inks requires a fair amount of working space, because all the bottles have to stand open. The twenty-one bottles I used required palettes—white plates roughly splitting up the reds, orange/yellows, and blues. My drawing board, with paper pinned on it, was propped at a low angle. The fruit bowl was in front of me and the plates, water, paper towels, and another plate for pens were placed to my left and right. Regular rinsing of dip pens is quite important; it doesn't take long for yellow inks to become green!

The top satsuma was my starting point.

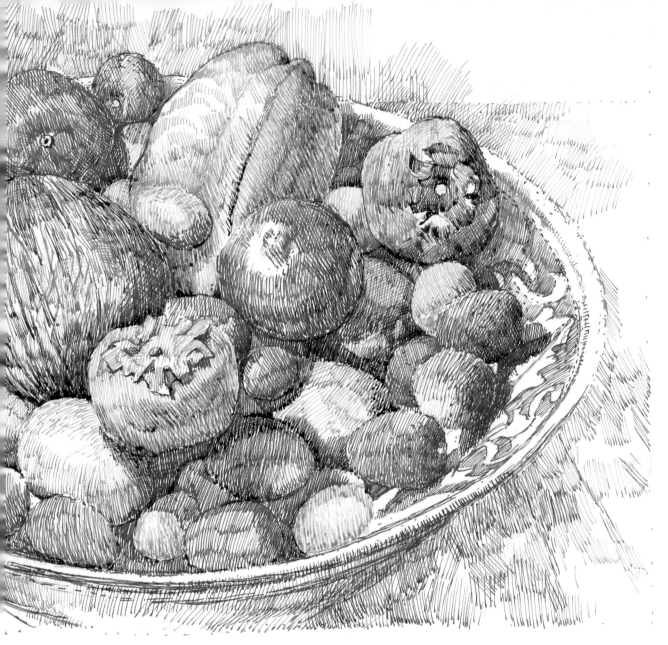

FRUIT, *Dip pen and colored ink*, 10 x 15 in (25 x 38 cm)

I placed dots over the whole drawing, planning my overall composition, but allowed for placements to be adjusted as the drawing developed. Each ink was used in its undiluted state. The choice of starting colors was based on the obvious: orange ink for satsumas, green for the star fruit, pink for lychees, blue with touches of green for the bowl.

Cross-hatching with a range of colors, I then modified the color of each fruit and modeled their shapes. There was much reflected light and color as well. I was careful not to enrich deep shadow hues too much, as that might cause the colors to become a murky brown.

Cross-hatching can become too busy-looking in areas that need to be calmer for contrast, so I kept the bowl as simple as possible and the table surface beyond it only lightly suggested. Colored ink applied with a dip pen does not lend itself to large areas of dark tones. Instead, use them for accents only, here and there.

DRAWING SILVER OBJECTS

Some drawing materials and certain papers seem to combine to suggest a particular quality rather well; change one element and that quality can slip away. Here, warm, dark-gray paper and white pencil suggest the shiny, reflective surface of silver.

This drawing was made as one of a series in which the myriad of shapes, of the objects themselves and of their reflections, are seen as areas of cross-hatched tones. I avoided outlining the objects, instead describing their edges with areas of tone, such as the edge of the tray.

My drawing started with very faint marks as I sorted out volumes and spaces and calculated proportions and ratios of the whole subject. Then I added stronger lines all over the drawing, but without dwelling on any one part. I continued this drizzle of marks until my drawing was completed.

Sometimes in a drawing the subject takes over and we use our materials in any way possible to achieve our finished drawing. In this case, while I used my pencil rather lightly, ultimately it does describe my subject. The marks are clearly seen, and it is their cumulative effect that can be read as silver objects on a silver tray.

(RIGHT) SILVER TRAY, *White pencil*,
18 x 16 in (46 x 41 cm)

SILVER TRAY (DETAIL)

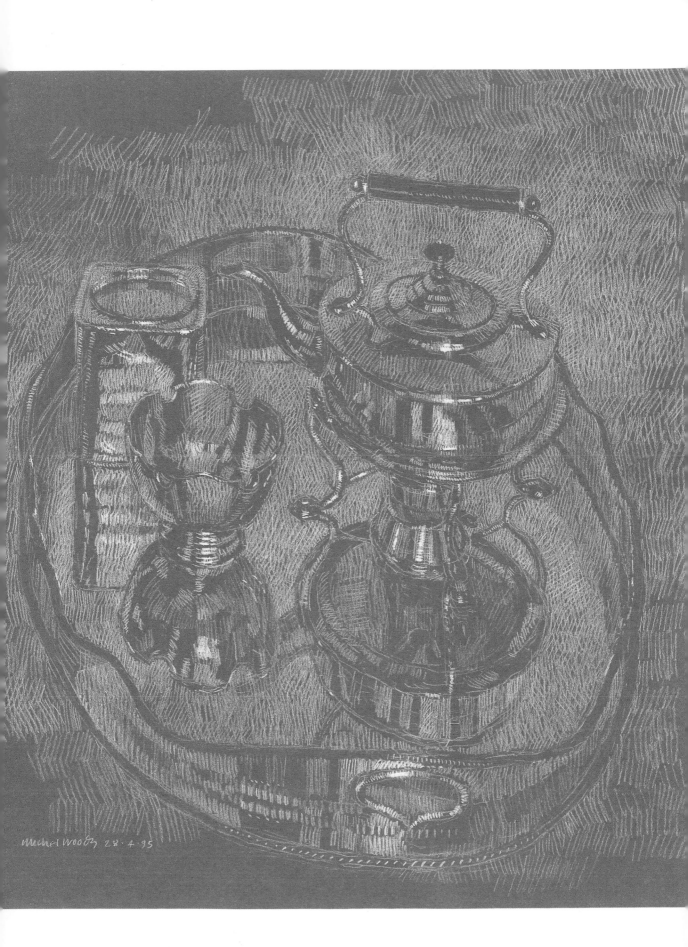

Michael Wood 28·4·95

EXERCISE—DRAWING GLASS

The transparency, colors, and reflections of glass are largely unpredictable. To make the most of their transluscent quality, place glass bottles on and against white paper and light them with a spotlight from the left. I chose water-soluble colored pencils for this study, as they combine color, line, and wash.

Stage One
If, as here, the bottles are old, some of their shapes will be irregular. When working out their placement on drawing paper, this becomes more apparent. The brightest reflections should be considered right at the start, because highlights will have to be reserved as white paper. Where the bottles stand in relationship with one another is also important, and the space between them needs thought.

Stage Two
The development of shading has to take account of the wetting to come. On the whole, most shading will be accomplished by washes carrying both dark and paler tones to shadow areas. This sort of drawing needs a lot of practice, for only when you know what happens in the end can you assess what the earlier stages should be. Also, sometimes just a hint of one pencil color can be applied to an area, like the bareful visible ochre at the base of the smallest bottle. Note even subtler yellow touches on the green bottle behind it.

STAGE TWO

Stage Three
Using a flat sable brush, when you wet the green bottle on the left, the yellow becomes more noticeable. It is important to wash your brush between areas because color will be picked up. The wetting of the blue bottle will be more dramatic because there is likely to be considerably more pigment on the paper. Keep the vital highlight clear.

STAGE ONE

Wash makes new boundaries, so be careful to maintain the bottles' shapes. Wet the two remaining green bottles and then the small, clear-glass bottle, where much of its interior remains untouched. Immediately wet cast-shadow areas, and since adjacent bottle areas will still be damp, there should be a little bleeding, which will soften and prevent edges from being unduly sharp.

The direction of wetting is also a drawing technique, for the brush will take pigment from whatever it passes over. Had a wet brush been used horizontally on the blue bottle, green areas on either side would have been affected. In another drawing, this could be used to advantage to produce subtly blended tones.

Palette of water-soluble colored pencils (Caran D'Ache Supracolor II)

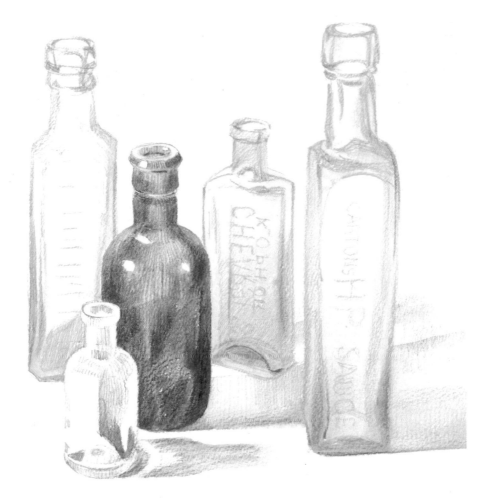

Bottles, *Water-soluble colored pencils,* 9 x 9 in (23 x 23 cm)

Demonstration

Draped material

Studies of drapery made by great draftsmen of the past are always handsome. Obviously, knowledge gained through such studies gave great artists their superb handling ability when painting figures in flowing clothes.

The material in this drawing was new, heavy denim. Being new, it had a stiff quality which draped well for drawing purposes. I arranged the fabric by lifting and lowering it gently so that folds and creases occurred naturally. It took about six attempts before I was satisfied with the shapes. When you use charcoal, as here, it's best to confine the medium to drawings that are of a reasonably large size.

MATERIALS
• Willow charcoal

PAPER
• Cream, lightly textured, 135 lb.

DRAWING TIME
• 2 hours

Method

1 The lighting focused on the central area of my fabric became my starting point. Although at first one might think that subjects like this are made up of curves, a closer analysis of the characteristics reveals a series of many straight lines, linked by short curves. Because of the way the material folded, most of the form boundaries were dark areas, so any early lines would eventually be absorbed into them.

2 I made the modeling of the folds with very lightly applied lines, but charcoal is so soft that they came out fairly heavy anyway. I tried not to complete any single area, but rather worked around all the shapes and gradations, including the table, adding a bit to each but in so doing, building a unified series of surfaces.

3 While erasing harms the surface texture of this type drawing, it is usually necessary because it is so easy to overstate, particularly pale tones. Sometimes it is easier to take a lot of tone off right up to a very dark area, and then rework from the dark again. Do not rub eraser fragments away with fingers or you will smudge your drawing; blow them away instead.

4 Although the background had been developed with the fabric, it was not complete. In the final stage, I built up background tone and drew the table texture, rendering it in lines that followed the perspective of my layout.

5 Fixative is vital for the final stage, as charcoal is really a black dust and needs something to help it adhere to the paper's surface.

Willow charcoal stick

Conté charcoal pencil

Charcoal pencil

Marks created by different charcoals

Some marks can simply build up the tone of an area

Viewed from a distance, the remaining spots of paper will keep an area alive

Large areas of dark can be built up toward the end of the drawing

Some marks describe the form

An area where an eraser has been used to lift off over-dark marks

Thick material produces fat folds

Many folds are made up of straight lines linked by short curves

The lightest areas have no charcoal on them at all

Modeling created by hatched lines

Some marks can follow the curve of the material

Directional marks describe the texture and the perspective of the table

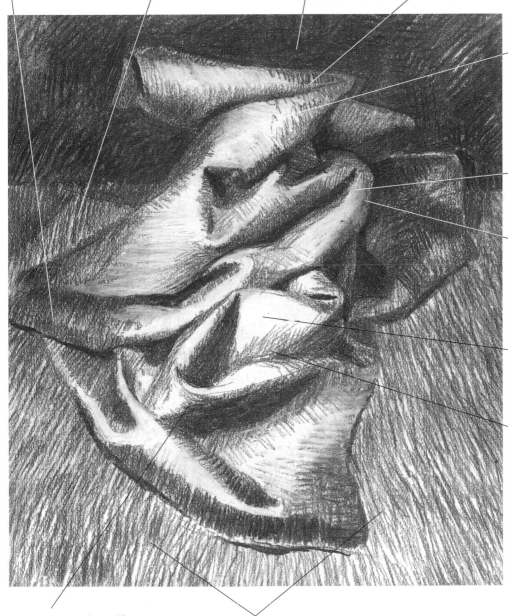

DRAPED MATERIAL, *Willow charcoal*, 19 x 16 in (48 x 41 cm)

EXERCISE—MIXED MEDIA

Sometimes mixed media can produce just the right qualities in depicting complex objects. These quail eggs call for two completely different drawing tasks. On the one hand, they are fragile, smooth, tan shapes, but on the other, their distinct image comes from a quite random and blotchy brown spotting.

For the background, I deliberately selected a brown pencil that is quite hard, making it difficult to apply an over-dark mark. For the pale-tan shells, it was an ideal choice. For the blotchy spots, I chose brown ink.

Stage One
Using your hard brown pencil, establish the placement of each egg, making very faint outlines to describe their shape.

STAGE 1

Stage Two
Use pale shading to model the eggs and their cast shadows.

STAGE 2

Stage Three
Apply a hard blue pencil lightly to add a slight hint of tone, working it alternately with pale brown to develop the modeling further.

STAGE 3

Stage Four
With a size 0 sable brush, paint the brown ink spots. Observe how the blotches vary in size, shape, and color intensity, and how they curve over the edge of the egg. The fact that it may be difficult to apply the ink in an even tone is an advantage here, for that is just what is wanted—variations in the brown blotches. When the ink is dry, use a hard gray pencil to give final strengthening to the shadow modeling and cast shadows.

STAGE 4

QUAIL EGGS, *Colored pencils, and brush and brown ink,* 5 x 8 in (13 x 20 cm)

STRUCTURAL PATTERN

Whereas the eggs on the previous page have a random pattern, these artichokes have a structural design of regularly repeated shapes. They also have a decided volume, so your drawing must suggest three dimensions. Note that while the leaves work in a spiral, at the same time, diagonal relationships exist.

Holding an object like this in your hand is enormously helpful. Turn it around, and also look at it from above and below to help you see every aspect of nature's design. Once you understand the artichoke's intricate structure, your drawing of it can be made with much more assurance and accuracy.

Set the artichoke stems in a block of florist's foam and light them from the right front. Overall, their left sides will be in less light, but the shape of each leaf will be quite visible, showing a good range of both light and dark tones. According to its place on the whole head, the leaf's light pattern will vary, with reflected light adding more variations here and there. The pressure that you exert in applying both white and black pencils will bring part of the tonal range, while the gray paper itself will take over to impart halftones where pencil marks fade out.

TWO ARTICHOKES, *Black and white pencils,* 14 x 15 in (36 x 38 cm)

POSITIVE AND NEGATIVE

Most drawings are based on the assumption that dark marks should be made on a light surface. For many subjects and situations that formula works admirably. But every now and then, rethinking that relationship can alter it to the artist's advantage, as happens in this case, where studies using both light on dark and dark on light are shown.

Mushrooms are excellent subjects for both approaches. Four of these studies use black lines and dots to define two main, contrasting textures. The lines follow the gills of the underside. Their spacing and thickness create both light and form. To lend contrast, the upper surfaces seem best described by dots, whose density creates deep shadows.

But the gills are in fact pale edges and not dark edges, so by using white ink on dark paper, it is possible to reverse the tones. The shadows need to be thought of right at the beginning, for they have to be left clear of marks, which, of course, is in contrast to the black pen drawings, where light areas have to be clear. The first white marks on dark paper tend to dry less white, but a second line will strengthen the white, adding a slight tonal difference. (Black ink is denser right from the start.)

FUNGI, *Pen and white acrylic ink,* 7 x 8 in (18 x 20 cm)

FUNGI, *Pen and black acrylic ink,*
11 x 4 in (28 x 10 cm)

DRAWING AT EXHIBITIONS

Great art collections and museum exhibitions provide a wealth of images to study. There is no better way to learn about drawing than to look at actual drawings. They reveal how the artist's hand worked and how the drawing was made in a way that few reproductions ever can. Never visit a museum without a small drawing book in your pocket, for to draw an object will focus your mind on it in a way that just looking may not.

CHALICE, *Pen and wash*, 6 x 5 in (15 x 13 cm)

Chalice I drew the above chalice in Florence, and made two extra sketches to record its base. One is a side view to clarify its edge, and the other a diagram of its overall shape.

CROSSBOWMAN, *Pen and wash*,
6 x 5 in (15 x 13 cm)

MAJOLICA POT, *Pen and wash*,
5 x 6 in (13 x 15 cm)

Crossbowman This was a ceramic figure from China on exhibition in London. The shadows came from wetting water-soluble ink after it had dried, which did much to enhance the drawing.

Mexican Pot The pattern on the opposite page was difficult to analyze. While it had to be drawn as a pot seen in the round, the pot's complex surface design had to be drawn as a cohesive geometric pattern.

Majolica Pot My interest in ceramics often prompts me to study surface patterns of pots. Of course, the ceramist draws patterns on a pot with a brush, so my pen sketch, above, does not try to copy the potter's work but rather to note its design elements and how they repeat.

Mexican Pot, *Pen and wash,* 6 x 6 in (15 x 15 cm)

Conclusion

This drawing was made from a full-size reconstruction of Leonardo da Vinci's flying machine when it was shown at an exhibition at the Hayward Gallery in London. Leonardo was always trying to push his inventive ideas forward. Many of them, and his research, exist in his drawings. In their own right they are superb, but perhaps for us at a humbler level they also serve to set a standard of drawing and inquiry by their very diversity of subject.

The opportunity exists for anyone to draw. The variety of subjects is vast, while the means are relatively simple. The enthusiasm, time, and practice that you bring to the art of drawing is up to you—but know that the rewards awaiting you can be enormous.

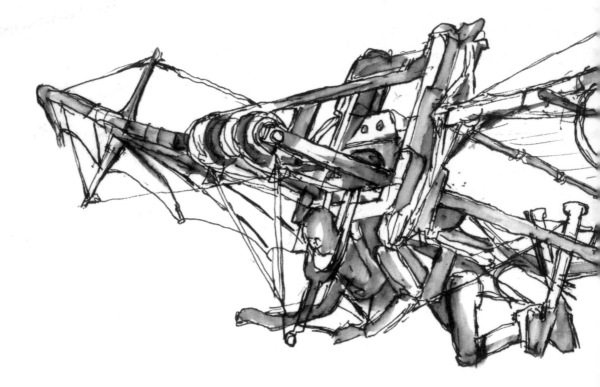

LEONARDO'S FLYING MACHINE, *Pen and wash*, 8 x 13 in (20 x 33 cm)

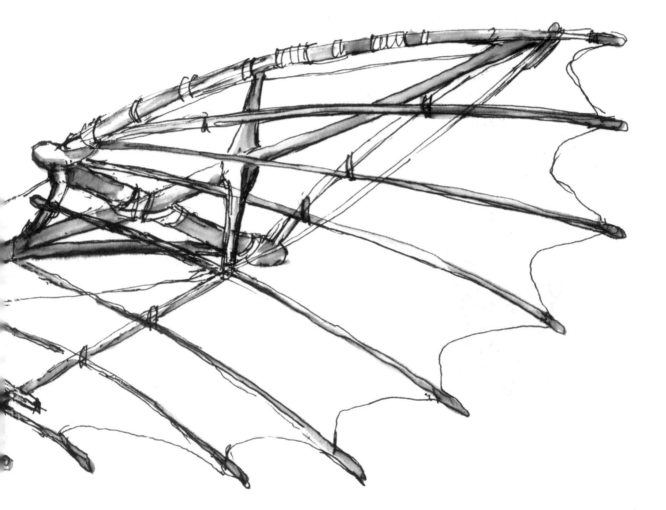

INDEX

9/21